Answers to 50 of the Most Often Asked Questions About

WATERCOLOR

GLAZING

TECHNIQUES

DON RANKIN

Watson-Guptill Publications/New York

This book is dedicated to my favorite aspiring artists: my daughter Carol and my son David.

May they use their precious talents to their full potential in the art careers they have chosen, and may they know as much joy in artistic expression as their father does.

Love,
Dad

Copyright © 1991 Don Rankin

First published in 1990 in the United States by Watson-Guptill Publications, a division of BPI Communications, Inc., 1515 Broadway, New York, N.Y. 10036.

Library of Congress Cataloging-in-Publication Data

Rankin, Don.
 Answers to 50 of the most often asked questions about watercolor glazing techniques / Don Rankin.
 p. cm.
 Includes index.
 ISBN 0-8230-4489-0
 1. Transparent watercolor painting—Technique. 2. Glazing.
 I. Title. II. Title: Answers to fifty of the most often asked questions about watercolor glazing techniques.
 ND2430.R36 1991
 751.42′2—dc20 90-28799
 CIP

Distributed in Europe, the Far East, Southeast and Central Asia, and South America by RotoVision S.A., 9 Route Suisse, CH-1295 Mies, Switzerland.

Manufactured in Singapore.

First printing, 1991

1 2 3 4 5 6 7 8 9 10/95 94 93 92 91

Text set in ITC Century
Captions set in Syntax

Contents

Introduction

This question-and-answer book owes its existence to the very favorable reactions generated by my previous books, *Painting from Sketches, Photographs, and the Imagination* and *Mastering Glazing Techniques in Watercolor.* In response, I've chosen to address the many genuine inquiries I've received by letter, by phone, and at various workshops from painters who seek to clarify certain issues and to learn more about specific techniques. Most of the material I've provided here pertains to the glazing technique, but this book will also shed light on watercolor in general.

For those of you who have not seen my other books, watercolor glazing means using multiple layers of watercolor washes to create the illusion of color and light. Each wash must dry before the next layer is applied, and staining colors should be used before colors that float on the surface of the paper, which are more easily disturbed even after they are dry. But you'll find out a lot more about this as you read on.

Those of you who are familiar with *Mastering Glazing Techniques in Watercolor* may see some areas of overlap, but I believe that *Fifty Questions* will offer you new material and new insights that will make it worthwhile to go back and re-examine familiar ideas in a fresh light. The emphasis this time is specifically on problem solving, in the hope that I can help you become a more proficient and self-assured watercolorist. I firmly believe that if you seek to grow as a painter, you absolutely *must* master the basics, or you will only find mediocrity and ultimate frustration.

Every question, answer, and illustration in this book is here for a reason. Be sure that you understand the approaches and the underlying reason for each step. I assume that many of you will copy some of the work found in these pages. Other readers will find suggestions for their own work; this is fine too. However, if you choose to copy, don't merely copy line for line or color for color, for in the final result you will only cheat yourself. Rather, copy thought for thought. Stop and ask yourself why I chose a certain color or a certain approach. By analyzing and investigating what I have done, you will learn not just to follow blindly but to plan your own paintings. You will find greater confidence in your work—and it will show.

Finally, I'd like to remind you that each of us is an individual. We do not all see alike, feel alike, think alike, or look alike—so why should we paint alike? In our diversity there is harmony, so that each of us can contribute our own unique abilities. In the beginning you may copy someone else who has journeyed a little farther than you. But as you grow you must inevitably find new ground. Dare to work and change things if you don't like where you are. It is really up to you.

It has been said that "the way that can be told is not the eternal way." For our purposes we can translate this to mean that good painting cannot be explained, but it can be experienced. Go for it.

DON RANKIN

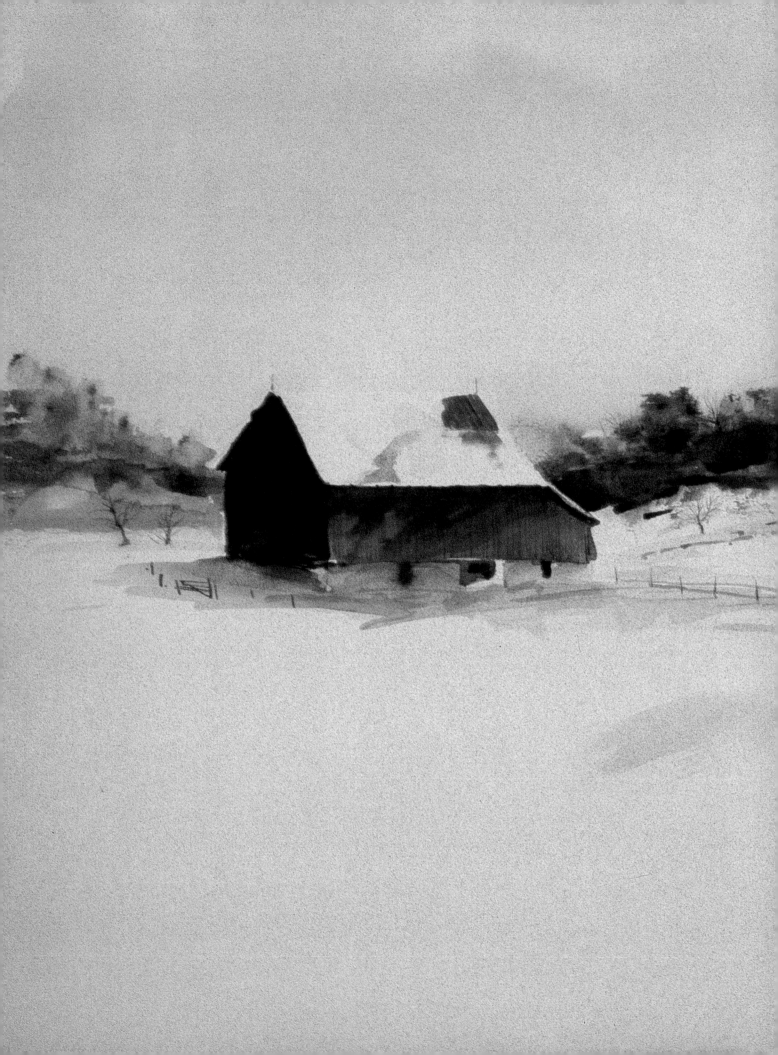

Materials

1

Q: What is the best kind of paper to use with the glazing technique?

It would be very simple just to name one brand of paper and let it go at that. However, several kinds of paper work very well with watercolor glazing techniques. Before we go on to look at and discuss specific brands of paper, let's discuss why choosing the right paper is so critical to the glazing approach to watercolor painting.

When you work in glazes, you put the paper through an endurance test. The application of multiple layers of watercolor wash creates a cycle of repeated wetting and drying that punishes the surface of the watercolor sheet. The paper must not only be strong enough to endure this, but provide a surface that will contribute to a vibrant, fresh wash, over and over again.

There are a few papers on the market that will provide this type of support—Fabriano Esportazione and D'Arches are two examples. Personally, I am partial to D'Arches 260 lb. cold-pressed "double elephant" for works that will require extensive washes. This strange name means simply that the sheet measures approximately 26 x 42″ (66 x 107 cm) in size. Cold-pressed means that the surface texture was produced by pressing the damp paper through a series of cold rollers. The surface has a texture just midway between rough and hot-pressed. (Hot-pressed paper, the smoothest, is passed through a series of hot rollers that literally iron the paper smooth.) The 260 lb. weight means that 500 sheets (1 ream) of this 26 x 42″ paper would weigh 260 lbs. But because these sheets are extra large, this weight is actually about the equivalent of 140 lb. in a 20 x 30″ (51 x 76 cm) sheet, a more typical size.

I use this paper because it has always worked predictably well for me. Although this sheet is thinner than some watercolor papers and therefore requires stretching, it doesn't soak up as much water as thicker sheets. The result is more vibrancy in my dried washes. For this reason it is relatively easy for me to use this brand as a standard. Any sheet lighter than 140 lbs. will not stand up to glazing. On the other hand, papers over 300 lbs. do not give the best color vibrancy, because the extra water they soak up dilutes the washes of color applied to them.

I don't recommend watercolor boards, for two reasons. The painting surface is usually a very thin sheet, about 90 lb., that will start to separate after a few washes have been applied. Usually after a few washes the color looks dull and tired. Their other problem is permanence. The backing is usually cardboard with an acidic pH level. Some boards have 140 lb. surface sheets, but I don't find these satisfactory either, because the top sheet is mounted to the cardboard with dry heat; many art conservators warn against using this type of support for lasting art.

The actual size of your paper should be dictated by your personal tastes, the scale of your painting, and your pocketbook. I use big paper because I paint a lot of large watercolors. I also find the paper to be the right size for tearing into several convenient pieces, so that I can get more than one good-size painting out of the same sheet.

There are exceptions to all these guidelines. One of the key exceptions is you: Your manner of painting, the amount of water you use, the number of washes you apply. All these things will make a profound difference in the brand of paper that works best for you.

I suggest that you experiment with other brands of paper like the ones included in this section for comparison. For best results, however, make sure that you select 100 percent rag papers that will take a lot of washes without separating or buckling. Keep your mixture of colors the same from one sheet to the next, and try not to vary the amount of water. Only by being consistent will you achieve results that will be useful to you.

A: There are several good 100 percent rag, neutral pH papers between 140 lbs. and 300 lbs. Experiment and find your own favorite.

For this comparison exercise, I have chosen papers that are readily available. (This test is certainly not an exhaustive study of all worthy papers!) If your favorite brand isn't among the ones tested, don't despair; test it yourself to see how it compares. And be sure to keep an open mind when trying new materials.

In the following examples I have used the same palette and similar subjects on fourteen different papers, in order to help you make an honest comparison of these sheets. Each one of these papers will produce an outstanding watercolor. Because of a variety of factors each paper has a personality of its own and it will impart a particular look to your work.

As you compare the papers, look at the three bars of primary color in the upper right corner, which are pure Grumbacher Thalo blue, Winsor red, and new gamboge from Winsor & Newton,

mixed with just enough water to produce a consistent wash. This will give you an idea of how well the sheet holds color. When painting the sketches I took great pains to apply the same strength of color to each sheet—but, as with any handmade effort, there are variations.

Also pay attention to the quality of the color and the contrast in values. See which washes look most vibrant, where the color seems most inviting, whether there are there any splotches, and so on. Also note the areas on the color blocks where color has been scrubbed out. This will give you an idea of how easy or difficult it is to remove color from the sheet. Remember, you will be applying layer upon layer of color, so you want a sheet that is reliable but one that will allow you to manipulate several layers of color without washing off the previous layers. This is the secret to clean, vibrant watercolor washes.

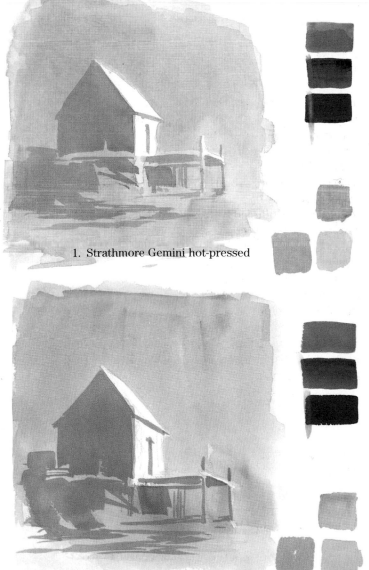

1. Strathmore Gemini hot-pressed

Sheets 1 and 2: Compare these two Strathmore sheets, both of which take the glazing well. However, in some places the wash on sheet 1 imparts a more vibrant, crisp color and the edges of the wash are definitely sharper. Compare the color blocks and you will see that the wash is more easily removed from the hot-pressed surface than from the cold-pressed. The cold-pressed surface gives the watercolor a softer appearance—yet both sheets give an overall soft, pearly quality to the color.

2. Strathmore Gemini cold-pressed

THE BEST PAPERS FOR GLAZING

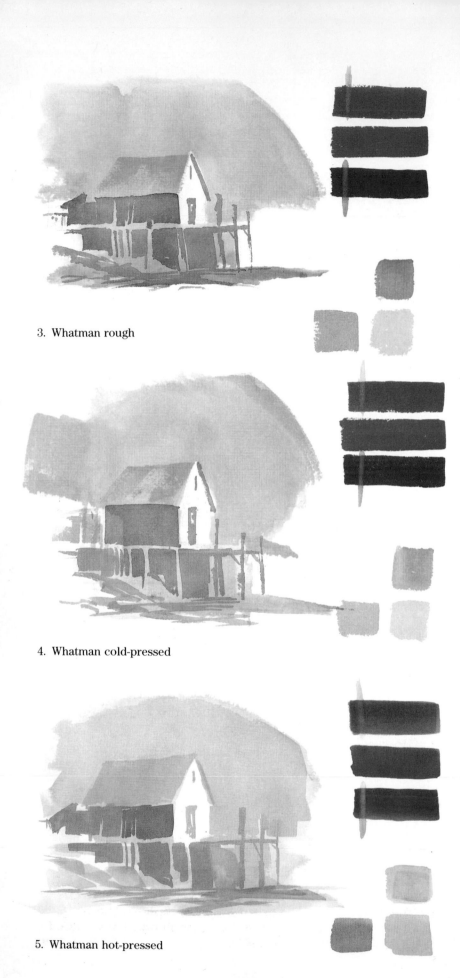

3. Whatman rough

4. Whatman cold-pressed

5. Whatman hot-pressed

Sheets 3, 4, and 5, left: All three of these Whatman sheets are of the same weight. Sheets 3 and 4 look very similar; the images appear soft and dreamy. The rough surface of sheet 3 might add a little more character to the image and make the darks a little stronger. However, sheet 5 has some decided differences. First, the sheet resisted taking some of the color—especially the yellow—as readily as sheets 3 and 4. On the other hand, it took the red very easily. The dark is also stronger. This variation should serve as a reminder always to test new papers before you begin a major work. One final thing about the Whatman papers: Notice that the color scrubs off the paper a little more easily than some of the other sheets tested here.

THE BEST PAPERS FOR GLAZING

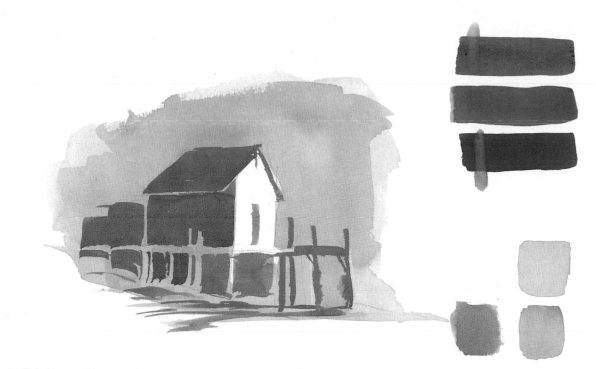

6. Fabriano cold-pressed

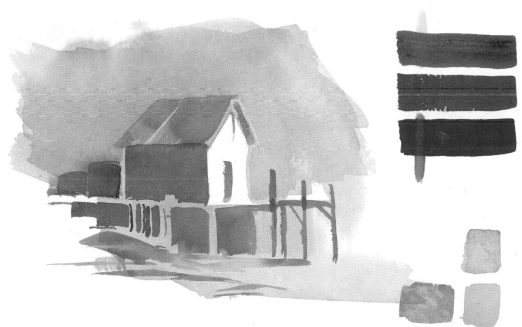

7. Fabriano rough

Sheets 6 and 7, above: As I stated earlier, I use a lot of Fabriano. This is a handmade 100 percent cotton paper. I especially like the cheerful, vibrant color it produces. However, you will find the surface of this paper somewhat atypical. The cold-pressed sheet has a surface similar to most other hot-pressed papers, and the rough sheet is similar to most other cold-pressed surfaces. For me this Italian sheet reflects a little of the color and personality of Italy. I use it often for lighter, more vibrant works where I will not be applying more than two or three layers of wash—Fabriano's surface sizing is a little less absorbent than that of some other papers.

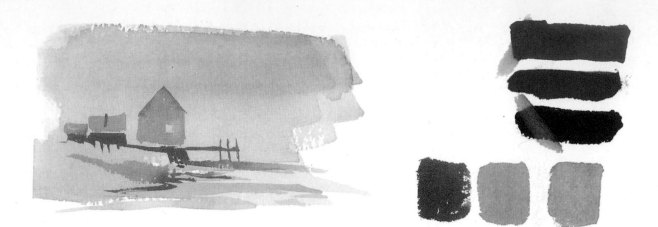

8. Saunders Waterford cold-pressed

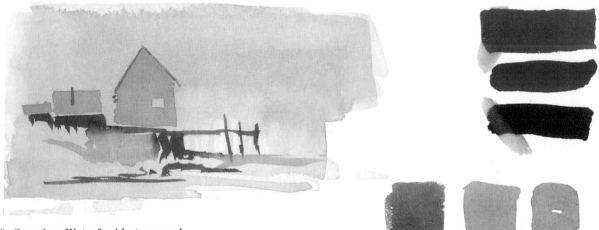

9. Saunders Waterford hot-pressed

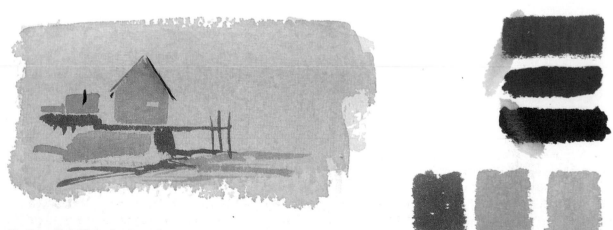

10. Saunders Waterford rough

Sheets 8, 9 and 10, facing page: All three Saunders Waterford papers are made of 100 percent long cotton fiber. Once again notice that the hot-pressed paper resists taking some of the color as readily, particularly yellow, while taking the red nicely. The color retention quality is good, and overall the sheets are quite pleasant to work with.

Sheet 11, below, is Saunders Bockingford, a good student-grade paper also made by Saunders. With economy in mind, it is made from a cleaned and buffered wood pulp instead of cotton fibers. However, it does hold up to glazing and yields a somewhat brighter color quality than its rag counterparts.

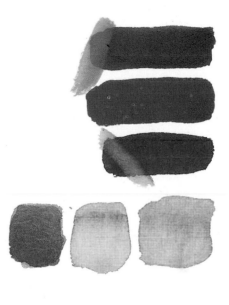

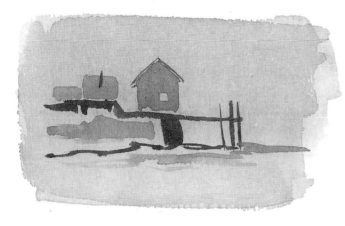

11. Saunders Bockingford

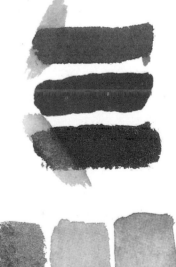

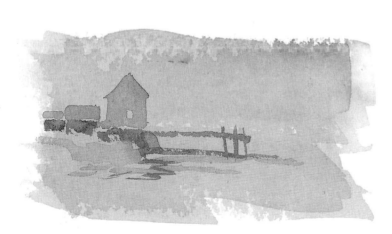

12. Meirat Velazquez blanco marfil

Sheet 12, above: Meirat Velazquez, a Spanish paper, is handmade of linen rag and is available in a variety of sizes and weights. The weight of this example is 300 gr/m², almost as heavy as a 140 lb. sheet. The color retention is good, and so are the handling properties. Personally, I like the surface texture of this paper very much. The price of this watercolor paper is a little more than some are accustomed to paying. However, it is a beautiful handmade sheet and it gives lovely results with a charming overall glow. It is a good paper to try if you are looking for a new texture.

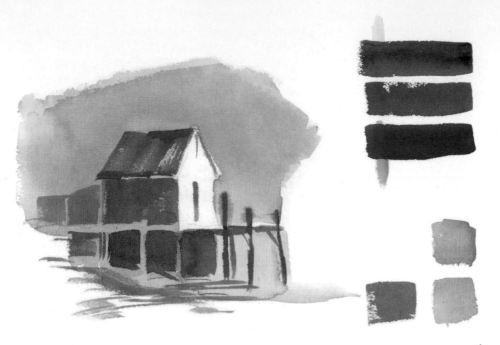

13. D'Arches cold-pressed

Sheets 13 and 14, left:
For many years I have used this French paper for most of my paintings. D'Arches is made from linen rag, and the sizing used on it provides an excellent surface for the glazing technique. I have had very few unpleasant surprises when applying layers of wash over it. D'Arches cold-pressed paper behaves very differently from the hot-pressed. The cold-pressed sheet seems to hold more color than the hot-pressed. This is most dramatically displayed in the shadow areas. In fact, the D'Arches cold-pressed seems to retain more vibrant color than any other sheet illustrated here. Note especially the roof color.

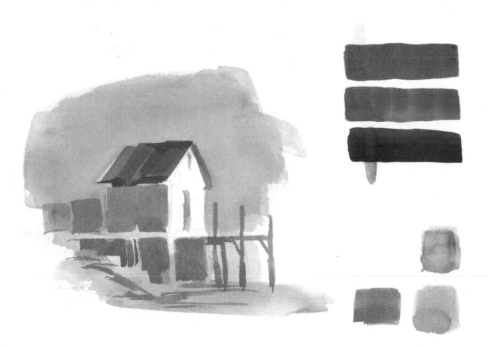

14. D'Arches hot-pressed

2

Q: Is it really necessary to stretch the paper before beginning to paint?

If you don't stretch your paper, you run the risk of having blotchy, uneven passages of wash. This is because unstretched paper tends to wrinkle into "hills and valleys" when it is dampened. You then get "explosions" and all kinds of irregularities in your washes—or, at best, uneven coverage.

The tendency to buckle depends largely on how the sheet is made, not necessarily on the paper's weight. But generally speaking, paper with a weight of 140 to 260 lbs. will usually require stretching if you use the full sheet. Sometimes you can get away without stretching a small piece—9 x 12" (23 x 30 cm) or slightly larger. Another key factor is the amount of water you use.

"Stretching" is a misleading term because watercolorists don't really stretch the paper; they let it stretch itself. (Some people ruin a good sheet of paper by pulling the wet paper drum-tight before they staple it!) All you have to do is to apply the paper to the work surface, gently pat out the bubbles beneath the sheet, and either staple or tape the edges. As the paper dries its natural contraction will draw the paper smooth. Wet paper is very vulnerable to damage, so don't put a lot of pressure on it or drag anything across it.

What's the difference between soaking the paper in cold or warm water? The warmer the water, the more sizing you remove from the paper, and the more water the paper will soak up later. I prefer to dampen my sheets in cold water, so that my washes will flow smoothly across the paper rather than soaking in.

A: Yes, it is important to stretch the paper, because most papers will otherwise buckle when wet, and you will lose control of your watercolor washes—which is particularly important with the glazing technique.

I stretch my paper on a piece of ⅜" (1 cm) marine-grade plywood, coated with two or three coats of clear varnish to seal it from moisture. You can attach your paper to the board with staples or freezer tape. (Masking tape won't work well because the damp paper resists the tape.) I use staples and generally start in the center of each edge and work toward the corner.

If you use Masonite or some other hard surface you will need to use freezer tape rather than staples. After applying the freezer tape, rub it down firmly for a good tight seal. Freezer tape dries as the paper dries and will hold the sheet securely while you work.

3

Q: Can I use the glazing technique on hot-pressed illustration board with a plate finish?

Some kinds of illustration board have a very slick surface, even less absorbent than a hot-pressed watercolor sheet. One of the greatest challenges in working on something so smooth is that your color will "crawl" over the surface instead of staying where you put it. There is no tooth or absorbency to drink up your washes; they are going to lie on the surface till they evaporate. This can be a blessing or a curse—it's up to you and your approach. The advantage of a plate finish is that *if* you can keep your color transparent, it will show a decided increase in intensity.

You must be very careful in applying new washes. If you are not very careful, you will lift off what is already there. (In some instances the ease of lifting out color can work to your advantage.) If you do not want to lose previous washes, it is especially important to rely on the staining colors (such as new gamboge or Hooker's green) in the early stages of a painting. Since these colors tend to stain the paper, you have a better chance of keeping some of this color intact while applying additional washes. Also be sure not to use more water than you really need.

In spite of all the challenges involved, try working on very slick illustration board more than once. Experiment with any board that has an acceptable rag content. After all, if your experiment is a success and you like your painting, you'll be glad it is on good paper.

A: With the right approach you can use a very smooth illustration board. Just remember that the surface is tricky and full of unexpected surprises because the washes dry by evaporation only.

I chose a very slick, hot-pressed illustration board for *Tying Up* because I wanted vibrant color. After my initial sketch was in place I dampened the sky area, taking care to leave the beach and the boat dry. I then flooded the sky with a wash of dilute Thalo blue, picked up the board in my hands, and rotated it to direct the flow of color toward certain areas. (On a slick sheet, this method gives a cleaner wash than a brush.)

After the surface was totally dry, I decided that the sky needed a little more life, so I dampened it again, using a clean brush and a very light touch. Into this dampened area I added a mixture of Thalo blue and manganese blue. Again I let it flow around until I liked the effect, and then I placed the board on a flat drawing table to dry.

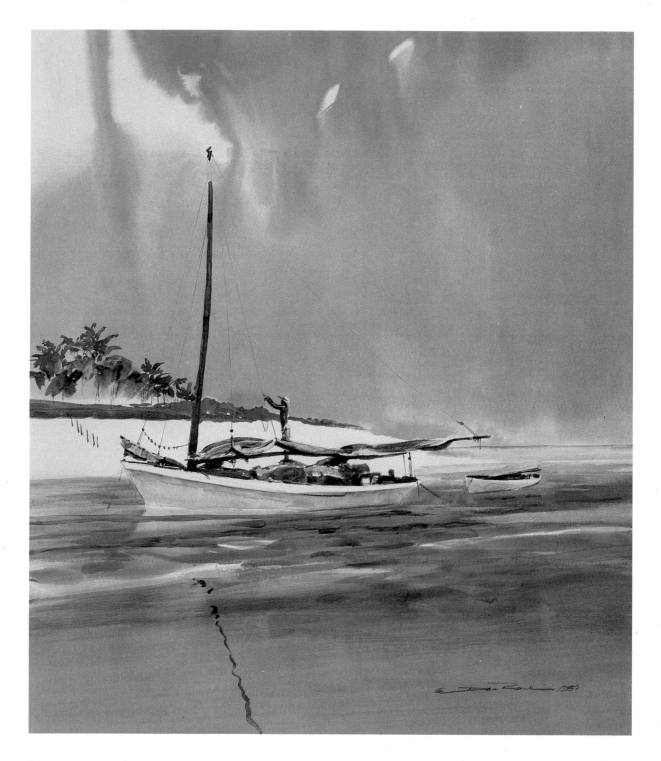

Tying Up. Watercolor on 14-ply Strathmore hot-pressed illustration board (240-2), 24 x 20″ (61 x 51 cm). Private collection.

The water area consists of Thalo blue for shadow areas, manganese blue, and small amounts of pale new gamboge. These colors were applied with a square-edged brush in strokes intended to create a wavelike effect. The remaining sections of the painting—the foliage and the boat—were painted in a direct manner with less emphasis on wet-on-wet than in the previous stages.

Rectangular strokes from a square-edged brush can imitate the structure of rock. The first layer established basic shapes, and the second developed shadow areas and texture. I used a similar technique for the early stages of *Blue Quarry.*

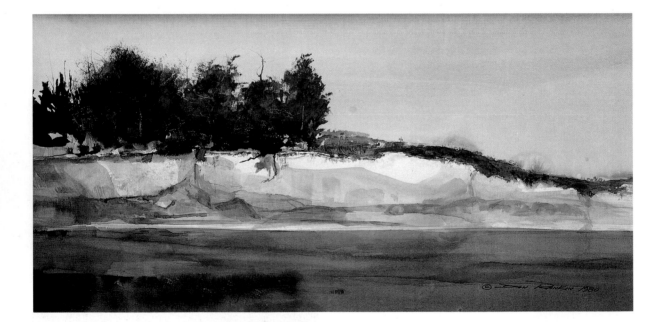

Blue Quarry. Watercolor on Strathmore hot-pressed rag illustration board, 10½ x 21¼" (27 x 54 cm). Collection of the artist.

The shapes and placement of these rocks have intrigued me for several years. I especially like using a hot-pressed surface for the sharp angles in the rocks. In working on a surface like this you need to have a plan of action. Know where you want to place the lights and darks in your composition and then dive right in.

Much of the detailing in the rocks is the result of overlapping faint washes of blue and bluish red to build the rock texture. The trees are built up of layers of Thalo blue, Winsor red, and some indigo for limb and branch detailing.

The water was added last. I flooded a bold wash of Thalo blue and manganese blue over what had been the lower portion of the cliff. When it dried, the previous detailing of the cliff showed through, creating the effect of the rocks being reflected in the water.

4

Q: I like to use watercolor blocks. Can I use them with the glazing method?

A: Watercolor blocks are perfectly acceptable for the glazing technique—especially smaller, less complicated paintings. A single stretched sheet of good-quality paper is still preferable for larger works with many layers of glazing, however.

Absolutely. I always keep at least one block in the studio at all times. Watercolor blocks are very convenient to use since you can buy them in pads of 15 to 25 sheets. Because all the sheets are gummed into place, you do not have to stretch any paper—which is certainly handy! After you finish your painting, you peel off the finished sheet and you are ready to start on the next fresh sheet in the stack. Since the paper is fairly thick, you don't have to worry about washes seeping through to the page below.

I use blocks for a lot of my smaller works and for small impromptu demonstrations in class. Although the paper will not take as many washes as a single sheet of D'Arches, it still provides some very nice results. However, for more involved projects, I still prefer a single sheet. After a lot of washes, a watercolor block can begin to come apart, causing wrinkling of the paper.

These are some of my favorite watercolor blocks. The one with the red cover is hot-pressed and the three with green covers are cold-pressed. All are 140 lb. and contain 25 sheets of paper.

Painting on a block is very convenient. You don't have to worry about stretching paper, or fighting it when it wrinkles. When you are through with the watercolor, peel it very carefully from the block, and you will have a new fresh surface ready for painting.

5

Q: I notice that you use a lot of cold-pressed paper. What happens if I use rough?

A: You can use rough paper as well as cold-pressed, but you will get a different look: more textured, and less suitable for fine details.

I like the texture of the cold-pressed surface and the results that I get from this sheet. From time to time I do use rough paper for a more textured look, which can be used to advantage. However, you will find that the cold-pressed surface allows you to obtain a finer degree of detail and a smoother look to your finished work. This is because the surface of rough paper often makes it difficult to negotiate fine details. Cold-pressed paper has a smoother surface that doesn't interfere with the tip of your brush as you are applying washes and details to your painting.

Both cold-pressed and rough papers serve a purpose. Every artist should become proficient with both surfaces, to be able to choose the most appropriate surface for any given project.

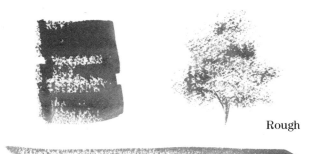

Cold-pressed

Rough

Here the cold-pressed sheet allows for fairly even coverage with a flat wash applied at a moderate speed, and there are areas of solid color both in the horizontal streak and in the tree subject.

Rough paper makes the brush skip over the surface of the painting, especially at a fast speed as in the horizontal streak. This is helpful for some textures but limits control.

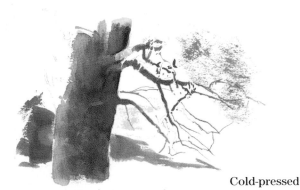

Cold-pressed

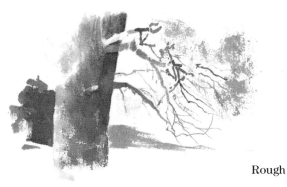

Rough

This unfinished study of an old oak tree shows an even, predictable surface. The cold-pressed paper lets you plan your textures more accurately for a more polished finished appearance than you could get on rough paper.

In the rough sample the color is broken up into a coarse texture. Notice that this also dilutes the strength of the color because it is a group of dots, not a solid wash. But with foresight you can intensify the color to compensate.

Q: Does the weight of my paper affect the quality of the color in my glazes?

A: Yes, the color is significantly affected by the weight of the paper you use. I've found that papers of about 140 lb. weight work best for me.

The weight of the paper definitely affects the quality of color. This is why I paint almost exclusively on paper of about 140 lb. weight. Lighter sheets may produce colors as vibrant, but they do not age well. Heavier sheets soak up a lot of color, as mentioned earlier, so that you must greatly overcompensate in your washes to prevent fading.

Test some papers of different weights yourself, because seeing is believing. Your results may vary, depending on a variety of factors. For an immediate comparison, look at the samples reproduced here. Each brand of paper is clearly labeled. Note the variations not only among brands, but among weights in the same brand.

I chose three brands of paper that offered a range of weights, and painted primary colors (Thalo blue, new gamboge, and Winsor red) as uniformly as possible on each. As you examine the samples, look for variations or particular characteristics from brand to brand. For example, does one brand hold red better than another? Does another brand allow the blue to fade out? Ask the same kinds of questions when you test papers on your own.

Bockingford 200 lb. cold-pressed

Bockingford 250 lb. cold-pressed

The red seems to hold its own on either Bockingford sheet. However, a closer look indicates that the yellow and blue dried lighter on the 250 lb. sheet.

As you compare these three D'Arches samples, it should be evident that the 140 lb. sheet has the most powerful and vibrant color. This is especially noticeable with the blue swatch, but it is also apparent with the red.

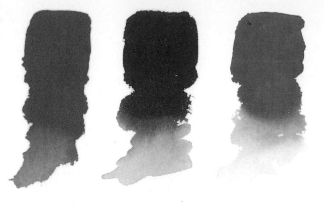

D'Arches 300 lb. cold-pressed

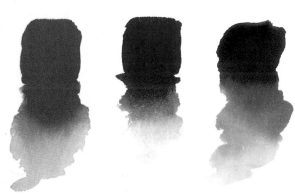

D'Arches 140 lb. cold-pressed

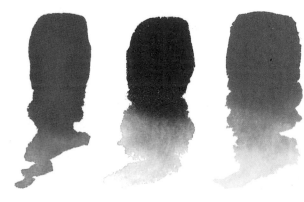

D'Arches 400 lb. cold-pressed

With these two Saunders sheets, it appears that the yellow stays about the same, while the red and blue are stronger on the 140 lb. sheet.

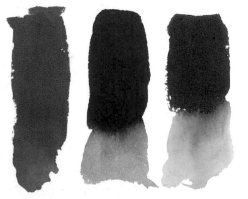

Saunders Waterford 140 lb.

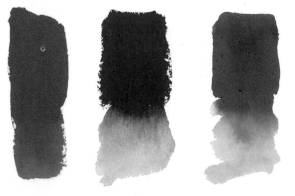

Saunders Waterford 260 lb.

THE BEST WEIGHTS OF PAPER FOR GLAZING

7

Q: Is there any particular brand of watercolor paint that is better for this technique?

Paint, like paper, can be a very personal choice among painters. Most artists have their own favorite brands. Yet from an objective standpoint, some brands of paint do exhibit better qualities for glazing than others. Personally, I rely on Winsor & Newton and Grumbacher for almost all my paints, because I have long experience with these two brands. I know what to expect from them in terms of handling qualities and color variations. However, two or three other brands are possibilities.

Naturally the first consideration when choosing paint should be permanence, or long-term stability. There are some tremendously powerful transparent dyes available that look very vibrant. However, some of them begin fading within a few months. Obviously this type of concentrated watercolor is not ideal for lasting paintings.

It is equally important that your paints be responsive and perform well on the paper. As you test various brands of watercolors, you will find that not all of them respond in the same manner. Some explode very quickly in a wet-on-wet technique, while others just lie on the sheet. Some seem to be smooth, while others have an oily character. The more you learn about different brands of paint, the more power you will have as a painter. You will discover combinations of brands that will allow you to create your own individual statement. As long as you stick to high-quality brands, your personal tastes will play an important role in the actual colors you finally choose.

One word of caution as you experiment, however: steer clear of student-grade paints. Most of them are made with synthetic pigments and are not formulated as carefully as artist-quality paints, and some contain binders that can look chalky. Therefore they do not perform as well. If you feel you must use student-grade colors, choose Winsor & Newton or Grumbacher, which at least are of higher quality than many of the others.

A: Certainly some brands of watercolor paints are better than others for glazing. Experiment with several good brands, and choose the colors you like best.

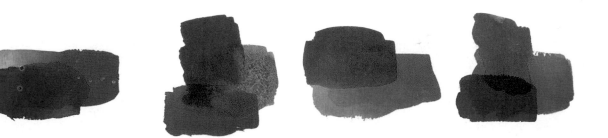

The brands of paint you choose will have a major effect on your work. Many lower-quality paints look great full strength, but they lose their even consistency or brightness of tone when diluted. Of course this hampers the artist in the accurate blending of colors.

Here I've chosen five brands of watercolor paints to compare, focusing on the following characteristics: pleasing color, good coverage with relative transparency, lively action on either wet or dry paper, ease of mixing with other colors, and relative strength when diluted. Once again I have attempted to keep these exercises as uniform as possible by using the same kind of paper, the same amount of water, and so on.

I used three colors, trying to match the primaries as closely as possible: vermilion deep, Indian yellow, and phthalo blue. (Various paint manufacturers give their colors different names and slightly different hues, so sometimes I had to substitute a slightly different color for my three basic primaries.)

At the top left I brushed in the red, yellow, and blue full strength. Next I immediately diluted each wash with clear water to determine each color's range of tonality. Below the three color bars I dampened a section of the paper with water, and then skimmed across it with the tip of an aquarelle brush loaded with phthalo blue. (I wanted to get an idea of how the paint behaved wet-on-wet.) For the final test I mixed phthalo blue and Indian yellow to create a landscape green. While this wash was drying I mixed some additional phthalo blue into it to create the trees, thus checking out the paint's handling properties: how easily it could be brushed on, blended, and so forth. Some of these differences in how it *feels* to work with the paint cannot, of course, be photographed!

Grumbacher

vermilion deep Indian yellow Thalo blue

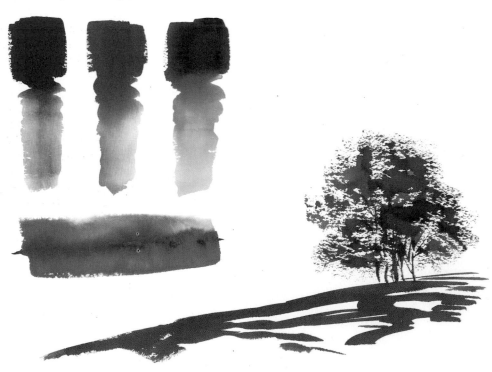

The whole Grumbacher sheet looks quite good. All the colors handle smoothly, the Thalo blue works very well in the wet-on-wet test, and the various greens mixed from yellow and blue maintain a vibrant tone.

Liquitex

vermilion hue gamboge phthalocyanine blue

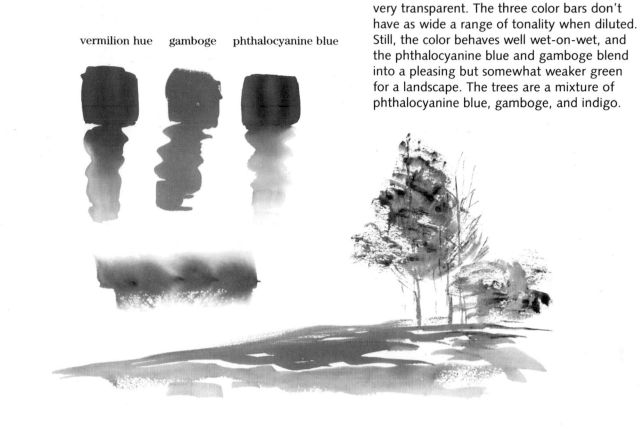

Here the color is decidedly thinner in body and very transparent. The three color bars don't have as wide a range of tonality when diluted. Still, the color behaves well wet-on-wet, and the phthalocyanine blue and gamboge blend into a pleasing but somewhat weaker green for a landscape. The trees are a mixture of phthalocyanine blue, gamboge, and indigo.

Maimeri

vermilion light gamboge ultramarine

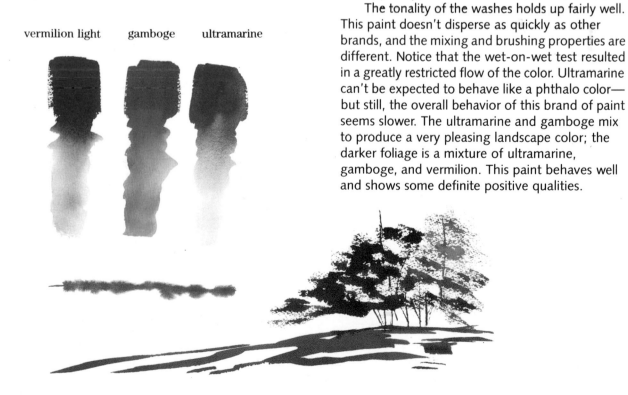

Although Maimeri does manufacture primary blue (cyan), I could not obtain it from any source. Consequently, I chose to substitute ultramarine.

The tonality of the washes holds up fairly well. This paint doesn't disperse as quickly as other brands, and the mixing and brushing properties are different. Notice that the wet-on-wet test resulted in a greatly restricted flow of the color. Ultramarine can't be expected to behave like a phthalo color—but still, the overall behavior of this brand of paint seems slower. The ultramarine and gamboge mix to produce a very pleasing landscape color; the darker foliage is a mixture of ultramarine, gamboge, and vermilion. This paint behaves well and shows some definite positive qualities.

Rembrandt

The three color bars behaved nicely with clean, smooth gradation of color. The wet-on-wet test also came out very well. The mixing of Rembrandt blue with gamboge produced a cool mint green, and the trees are a mixture of indigo, Rembrandt blue, and gamboge. Rembrandt holds up better than Liquitex when brushing these darker colors across the sheet.

vermillion gamboge Rembrandt blue

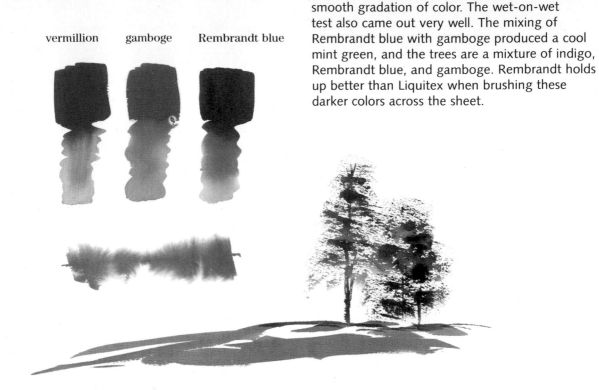

The three color bars here hold up nicely. The color has a smooth, consistent flow from the darkest value to the lightest edge, maintaining a crispness all the way through. The wet-on-wet section performs quite well too, and new gamboge and Winsor blue produce a superb landscape green. The darker foliage is a mixture of Winsor blue, indigo, and new gamboge. This sample sheet has colors far more vibrant and crisp than many of the others you've just seen.

Winsor & Newton

vermilion new gamboge Winsor blue

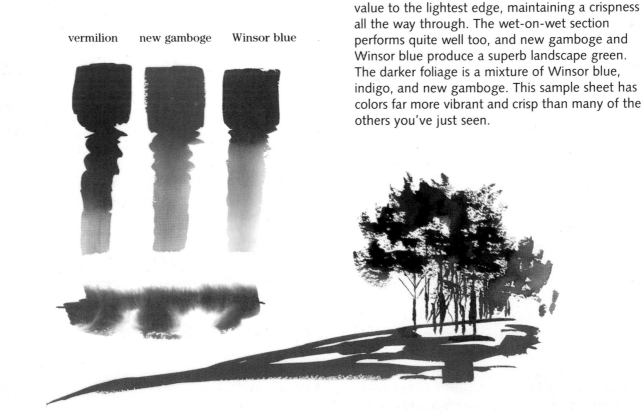

Q: Is it really necessary to paint with distilled or filtered water?

A: Pure water is always the safest for watercolor, and particularly for egg tempera. Depending on the purity of the water supply where you live, using filtered or distilled water is a good idea—a way to ensure the longevity of your work.

The answer to this question depends on where you live and the condition of your water source. I live near a fairly large city, and the municipal water supply that comes out of my tap contains fluoride and chlorine. Although they are supposedly present in small amounts, these chemicals are damaging to water-soluble paint pigments.

When I paint with egg tempera, I definitely use distilled water, because fluoride destroys the protein base in the egg, thereby ruining the paint. For watercolor painting I now compromise by using filtered water, thus removing the chlorine but not all of the fluoride. Yet I have also painted many a watercolor using the city water supply, and at this point there is no discernible difference. Who knows what will happen later as the pieces age?

When you are on a field trip, distilled water makes good sense since you must carry water anyway. It is easy to transport in a plastic bottle, and you can buy it in most large grocery stores. Even though that clear sparkling stream may look inviting, you may be inviting the wrong organisms to your watercolor party if you scoop up that water and use it to paint. (In the past, some watercolor painters were not too choosy about their source of water—unwittingly causing a nightmare for collectors, curators, and restorers.)

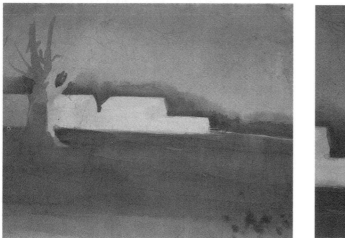 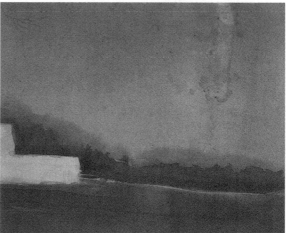

These photos show mold growth and other damage incurred by using contaminated water. Using distilled or filtered water is a little extra work, but it is surely worth the trouble to prevent ruining a painting you really like!

Q: Can I use other types of water-based paints with the glazing technique, or must I stick to watercolor?

A: It is possible to glaze with some other types of water-based paint, especially acrylics. I do not recommend glazing with gouache, casein, or house paint.

There are several kinds of water-based paint, including gouache, casein, egg tempera, acrylics, and even some house paints. Gouache and casein are designed to be opaque and provide covering power, so I wouldn't attempt to use them in glazing, except to provide final opaque accents for an otherwise glazed painting.

Both egg tempera and acrylic colors range from totally opaque to translucent to totally transparent. The transparent versions of each kind of paint can both be used for glazing. However, of all the water-based media, acrylics come closest to duplicating the look of watercolor. If you are devoted to painting in acrylics, just substitute your acrylic colors for their watercolor counterparts and glaze. Each layer of wash you apply will become waterproof as it dries, and eventually your layers will build up into a look slightly different from that of a watercolor. Even so, it is certainly possible to glaze with acrylics.

Some artists try using house paint from time to time, but I do not recommend this for glazing because house paints are certainly not intended to be transparent. Again, you must consider stability when choosing any paint. To make a house paint transparent, you would have to dilute it with so much water that you would drastically weaken the paint's binding agent, and the paint would not be able to form a lasting bond with the paper.

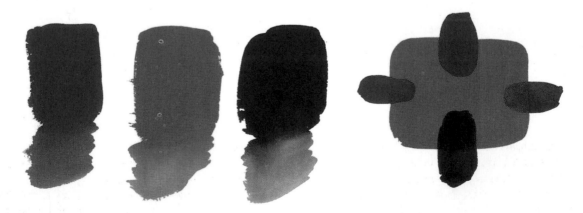

Here is a sample of gouache, which is strictly opaque. (It is often referred to as opaque designer's color, or opaque watercolor.) Most people who use gouache mix it to the consistency of heavy cream, and avoid diluting the color to a transparent level. When you dilute the color, the matte finish disappears and the resulting coverage is at best blotchy and unpredictable. This is not a good kind of paint to attempt to use for glazing.

The vertical swatches over the yellow block show how well the gouache covers another layer. The two horizontal swatches have been diluted to show that the paint can be thinned. However, the results are not satisfactory.

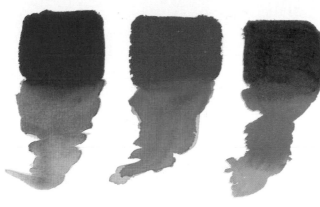

Here I chose three acrylic colors from Grumbacher: cadmium red light, hansa yellow medium, and Thalo blue. The top of each color bar is not impasto, but just a little thicker than ordinary watercolor. Below that, each color has been thinned out with water into a graded wash much like watercolor.

The yellow block to the right is an example of the versatility of acrylic. The yellow square was applied in an opaque manner. Once it was dry, the red and blue swatches were applied full strength at the top and bottom but greatly diluted on the right and left sides. Like full-strength gouache, full-strength acrylic is opaque enough to cover the previous color completely. Unlike gouache, acrylic also dilutes evenly enough to let the previous color bleed through, so that it can be used for glazing techniques.

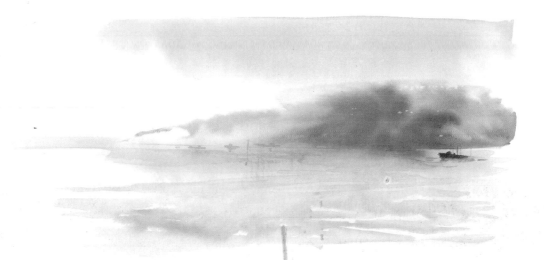

The final exercise shows a typical "watercolor" using the acrylic colors shown in the color bars. First I applied a wash of clear water to a large rectangular area of the paper, and into it brushed a wash of Thalo blue with a small amount of cadmium red light. This color flowed down into the foreground, but more slowly than watercolor would. You can see that some of it did not completely cover the sheet, thereby creating the misty effect on the left.

Once the sheet was dry I dampened the upper portion of the paper once more with clear water.

Using a darker mixture of Thalo blue, hansa yellow, and cadmium red light, I began to create the shoreline. While this was drying, I brushed waves into the foreground water, using alternating strokes. Using a dampened brush I smoothed the edges of some of the washes to create some variety. The neutral gray in the middle of the water is a mixture of cadmium red light and Thalo blue. The boats are of the same color mixture, but darker in value, and the darkest boat on the right side of the picture is made of an even stronger portion of this color mixture.

10

Q: How can I tell whether my colors are really transparent?

The term "transparent" is relative. All watercolors manufactured by the major companies are considered transparent unless the label states otherwise. (For example, gouache, opaque designer's colors, and so on are opaque water media.) But even among supposedly transparent colors, the actual level of transparency varies considerably from brand to brand and from color to color. The best way to test for transparency is to perform a simple experiment: paint the color over a dark surface, such as dried India ink on watercolor paper. The more transparent the color, the less it will show up on a dark surface.

On pages 35–36 I've illustrated this testing technique with some of the most commonly used color ranges: yellows, reds, blues, violets, and umbers. (Although I normally mix my umbers and siennas from primaries for a cleaner, more vibrant color, some of the transparent oxides might make an interesting addition to your palette.) Note that I've displayed more than one brand side by side, which is useful for comparing variations in hue and temperature as well as transparency. Also note the sample of a graded wash beside each circle. This shows how *all* the washes were applied across the black circles. It is important to use graded washes for this test, because many colors are somewhat opaque at tube strength but transparent when diluted.

Try a similar test of your own, being sure to use graded washes. Understanding the various qualities of your paints will help you master the glazing technique. As you continue to experiment, you will discover that some colors are more appropriate than others at a certain stage of painting. A simple rule of thumb is to use the most transparent colors at the earliest stages and gradually build up to the most opaque ones.

A: Test your watercolors for transparency by painting a graded wash over a dark surface.

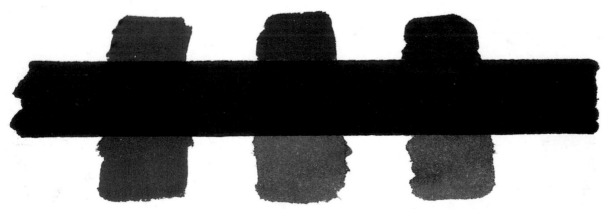

Grumbacher Thalo blue Winsor blue Rembrandt blue

Above: Here a test of three similar hues is reproduced closer to full size than are those on the next two pages. You can see that the Grumbacher Thalo blue is the most transparent, leaving the least chalky residue over the India ink.

Facing page: The most transparent colors are those that almost disappear as they cross the black. Grumbacher mauve and Winsor red, for example, are quite transparent even when applied near full strength. Compare them to the opaque, chalky look of Grumbacher cerulean blue or Rembrandt gamboge. Yet even an opaque color behaves almost like a transparent one if diluted enough.

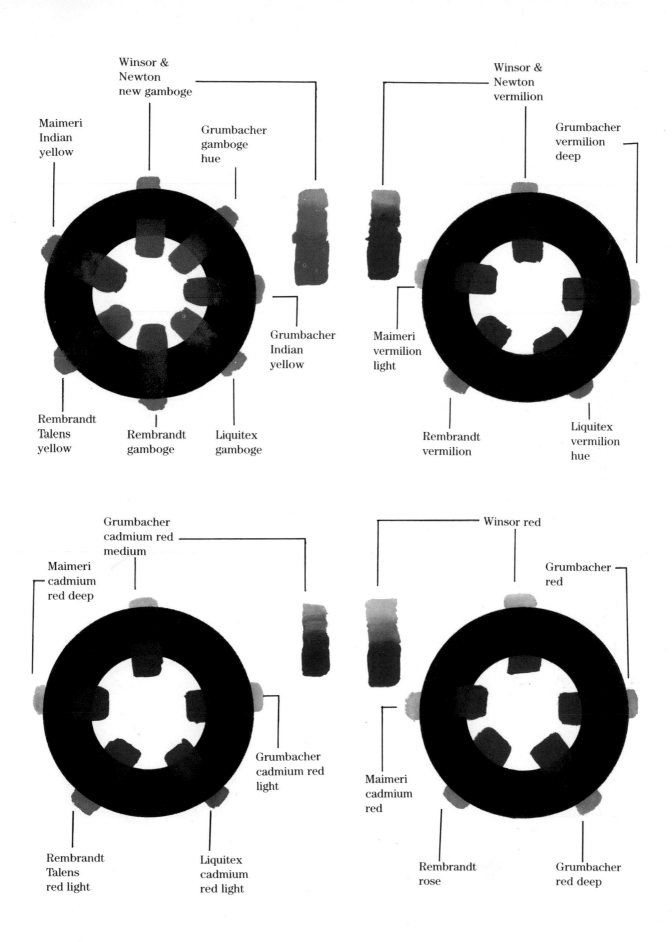

Maimeri
Indian
yellow

Winsor &
Newton
new gamboge

Grumbacher
gamboge
hue

Grumbacher
Indian
yellow

Rembrandt
Talens
yellow

Rembrandt
gamboge

Liquitex
gamboge

Winsor &
Newton
vermilion

Grumbacher
vermilion
deep

Maimeri
vermilion
light

Rembrandt
vermilion

Liquitex
vermilion
hue

Grumbacher
cadmium red
medium

Maimeri
cadmium
red deep

Grumbacher
cadmium red
light

Rembrandt
Talens
red light

Liquitex
cadmium
red light

Winsor red

Grumbacher
red

Maimeri
cadmium
red

Rembrandt
rose

Grumbacher
red deep

TESTING COLORS FOR TRANSPARENCY

Winsor violet

Maimeri violet lake

Grumbacher mauve

Rembrandt mauve

Rembrandt cobalt violet

Winsor & Newton cerulean blue

Maimeri cobalt blue

Grumbacher cerulean blue

Grumbacher cobalt blue

Winsor & Newton cobalt blue

Rembrandt cerulean blue

Winsor blue

Maimeri ultramarine

Grumbacher Thalo blue

Liquitex phthalocynanine blue

Grumbacher French ultramarine

Winsor & Newton French ultramarine

Rembrandt blue

Winsor & Newton raw sienna

Winsor & Newton burnt sienna

Maimeri burnt umber

Rembrandt transparent oxide brown

Rembrandt transparent oxide red

Rembrandt transparent oxide yellow

Winsor & Newton raw umber

Winsor & Newton burnt umber

11

Q: Do you use any brushes other than regular watercolor brushes for this technique?

You don't need anything unusual in order to glaze. Just make sure that you have good-quality watercolor brushes that are responsive to your touch. The brushes that you normally use in your watercolor sessions should perform very well for glazing. The only unorthodox brushes I use are two bristle brushes: a large one and occasionally a small one. These are not normally used by watercolor painters because they can easily scrub the surface of the paper. However, being careful to use a light touch, I use the large brush for covering large expanses of paper with both water and wash.

When I started painting, many people thought large watercolors were impossible to execute. Being unaware of this, I started painting 30 x 40″

(76 x 102 cm) watercolors, and I could not find suitably large watercolor brushes. Today there are several from which to choose, but old habits die hard and I still like using a size 20 Gainsborough from Grumbacher. Now and then I use a smaller bristle brush to scrub out a dried passage of color.

One more word of advice about brushes: Some watercolorists feel comfortable only when they have a tiny brush in their hand. Tiny brushes are fine for tiny details, usually the last touches you add to a painting. But in the earlier stages, a tiny brush makes it more difficult to think on a broad scale and to paint with a loose, free style. Don't fall into the habit of using a smaller brush than you really need.

A: Although standard watercolor brushes will do just fine, I also use large and small bristle brushes. Use whatever brushes feel comfortable to you—while being sure to use the largest possible brush for whatever you're painting.

These are my favorite brushes. Left to right: old bristle brush for scrubbing out; Grumbacher Gainsborough size 20 white bristle for large washes; Grumbacher 1-inch aquarelle; Grumbacher 1-inch number 3640 bristle for medium washes and adding textures; Grumbacher number 7357 rigger, size 5; and Winsor & Newton series 7 red sable, size 6.

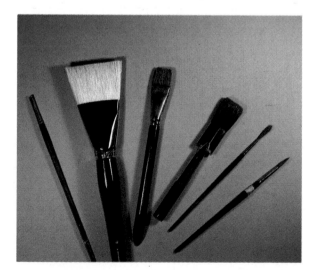

12

Q: I like to use sponges, tissues, paper towels, and other tools to create unusual effects. Can I still use these items with the glazing technique?

A: Many kinds of tools can be used with the glazing technique to create special textural effects.

Certainly! There is no reason for you to restrict yourself merely because you are glazing. The brush is a powerful tool, but it need not be the only one at your command. I use many different items for creating textures and unusual effects. The only difference in glazing as opposed to other watercolor approaches is that you are working in layers. Also, be careful to use a light touch with sponges and similar tools, so that you don't scrub or lift an earlier wash off the paper. A light touch also prevents a heavy build-up that can create an unwanted opaque effect.

Never stop broadening your visual vocabulary, or looking for new ways of creating textures and of depicting the old and familiar in a new, exciting way. Keep your visual imagination alive!

(For a more detailed answer to this question, look at the approaches used in Question 39, exploring different ways of creating textures.)

In this two-step example you see how I glazed a large, flat rock. First I established the preliminary shape, using a 1-inch aquarelle brush to paint flat washes. After this had dried, I used a sponge to model texture.

Here is a small maple tree whose foliage was created using a small natural sponge. Once the first layer had dried, the second layer of red was applied using the same sponge. I then added the trunk and shadow with a square-edged brush. All in all, this little tree was a very quick and simple operation.

For this small sketch of an approaching storm front, I also used some unusual painting tools. First I brushed in a mixture of Thalo blue and vermilion across the sky and water. When the sky was nearly dry, I pressed a small piece of wadded paper towel into the damp wash. The towel picked up the excess moisture along with the damp pigment, creating a cloud effect.

When the paper was completely dry, I dampened it again and strengthened the edges of the cloud with a little dark wash. After all these layers were dry, I applied another layer of color to the sky to help soften the lower edge of the cloud line, and I dragged the brush horizontally across the dry paper to create the illusion of sparkles in the water. The boats were added last.

Problem
Solving

13

Q: Isn't the glazing technique too difficult for most watercolor painters to master?

A: Glazing is not difficult, as long as you follow the necessary steps. It can be as simple or as complex as you like.

Like any other technique, glazing requires a little practice. Just be sure to use staining colors first, and to let each wash dry completely before you begin the next one. If you are unsure about how colors will combine, test them on scrap paper first.

The glazing technique can be as simple or as involved as you choose to make it. For example, all or only a portion of your watercolor may receive glazing. You may choose to develop an elaborate glowing sky with a very nondescript landscape, as in a sunset. In this case most or all of the glazing would be in the sky itself. On the other hand, you might use glazing to emphasize some small portion of a still life. Finally, you may choose to glaze your entire painting. The primary point is that the artist controls the level of complexity.

The following glazing exercise of an autumn leaf will show how you can carry the technique as far as you like. In fact, the degree of refinement can go well beyond the seven steps outlined here.

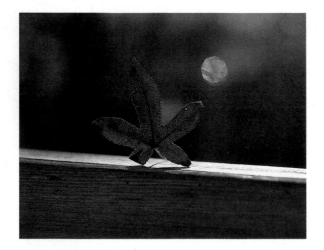
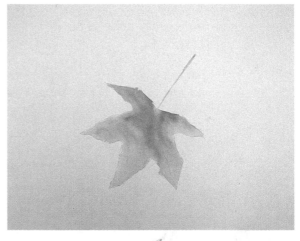

Step 1. I applied a layer of dilute new gamboge to the preliminary pencil outline, and allowed it to dry thoroughly. Note that the wash is not a flat tone; there are variations in the strength of the wash. Those variations approximate light and shadow. In later stages, they will translate the irregularities in the leaf surface.

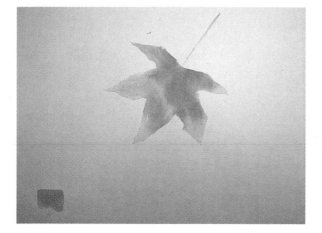

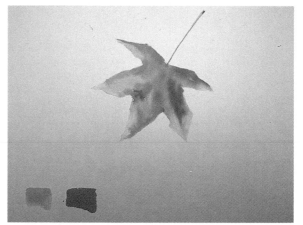

Step 2. After the paper had dried, I carefully dampened the leaf surface with clear water, staying within the drawn boundaries of the leaf shape. More new gamboge was applied. This time I allowed the wash to concentrate in select areas of the leaf. Since the surface was damp, the wash feathered out and produced soft edges on the interior of the leaf. Notice how this second application of wash tends to intensify the strength of the yellow in the overall leaf.

Step 3. Once the sheet was dry, I dampened the leaf surface again. The amount of water used each time was not great, certainly not enough to cause it to puddle and run over the borders. Into this dampened surface, I introduced a new shade of color by combining a little Grumbacher red to the new gamboge. I brushed the color in and allowed it to bleed on some edges while it began to form a definite ridge in the center of some of the leaf's fingerlike sections.

This step is as far as some painters might wish to develop this subject. The remaining steps are optional refinements of the leaf's texture.

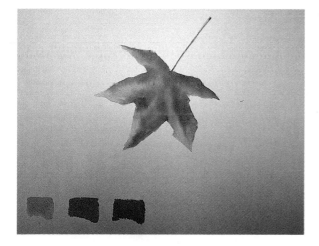

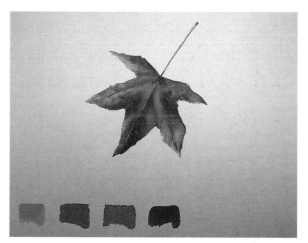

Step 4. After the paper was dry, it was time to refine the leaf a little more. This next wash contains a great deal of dilute Grumbacher red and a small amount of new gamboge. I applied it to the darker areas of the leaf. However, before the wash was applied, the entire leaf was dampened with clear water. This was done in order to maintain a soft feeling to these gradations of color. Basically, this is a controlled wet-on-wet technique.

Step 5. When the paper was completely dry, I prepared to refine the image even more. This wash of new gamboge and Grumbacher red with a very small amount of Thalo blue was stronger than any of the preceding washes. With clear water, I carefully dampened the entire leaf with the exception of some small areas on the right segment, the right side of the tip, and the main vein down the center of the leaf. The objective was to enlarge the shadow areas while refining some possible highlight areas.

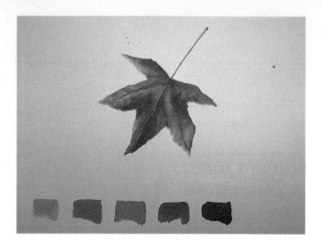

Step 6. Again with the paper completely dry, I began using a stronger version of the previous wash—increasing the amount of red and blue and decreasing the ratio of water. Much of this painting sequence was done in a direct manner (to dry paper), which creates sharper edges. The objective here was to begin to create definite texture. You will note that at this stage various minor yet significant details such as veins in the leaf begin to appear. Along the middle ridge you can see an area where a lighter wash was not covered, creating a highlight on the crest of the leaf ridge.

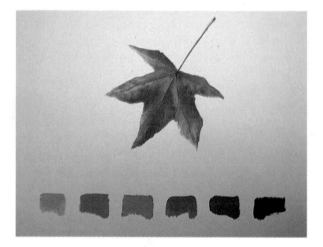

Step 7. In this last step, I applied the darkest value. This dark brown was a mixture of new gamboge, Grumbacher red, and Thalo blue. Most of these washes were painted in a direct manner. In some cases, I used the brush in a stippling manner, allowing the point to touch the surface to create dark concentrated spots of color. In other cases, the color was smudged with my finger to blend and create texture. The dark wash was applied directly to dry paper on the leaf stem and along the bottom edge of the right segment of the leaf.

14

Q: Is the glazing technique limited to creating only a few special effects?

A: No. Though you may not be able to glaze in an impasto technique or on canvas, you will be free to utilize other techniques to create numerous effects.

There are always physical limitations of one kind or another in any technique, and it's important to respect these. For example, when working in watercolor, you wouldn't be able to utilize an impasto technique; nor would you be able to work on canvas. However, aside from these obvious physical limitations, the only boundaries in this technique will be drawn by your ability and imagination. You can use special effects to incorporate the entire painting or just a specific area; the choice is completely up to you.

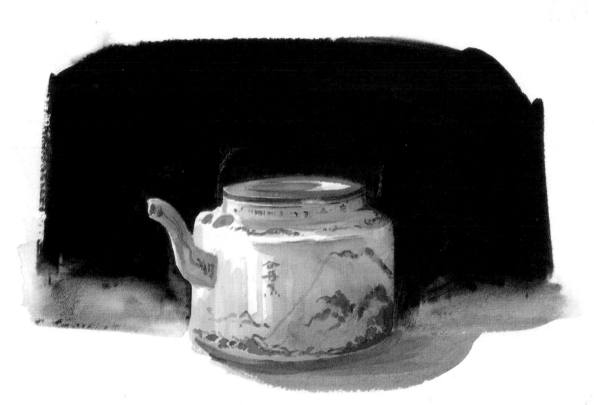

The only glazed area in this piece is on the teapot. Most of the glazing was confined to the shadow side of the pot, where I alternated washes of pale vermilion and pale Winsor violet. By limiting the amount of glazing and by using a very dark background, I was able to heighten the lighting effects to create a dramatic contrast.

The blue detailing is a combination of Thalo blue, cobalt blue, and ultramarine blue. I applied the cobalt and ultramarine blues in the later stages to prevent muddying the washes. By using a slow yet steady build-up of color through glazing, I was able to control the delicate lighting on this subject. This is one example of a specialized use of glazing.

15

Q: How long does it take to paint a watercolor using the glazing technique?

A: It could take a short or long period of time to glaze, depending on the complexity of your subject matter.

While the glazing technique does require more time—there are more steps involved and you have to allow drying time between steps—it would be a mistake to assume that the technique can't be executed rapidly. For example, on a warm day washes will dry very quickly, allowing you to make a lot of progress. I have painted some small watercolors in an hour or less. On the other side of the time frame, I have taken weeks to finish one piece. The best answer is that each painting is different. The prevailing weather condition, your objective in the painting, and the complexity of the subject are all factors that will dictate the length of time it will take you to complete your painting.

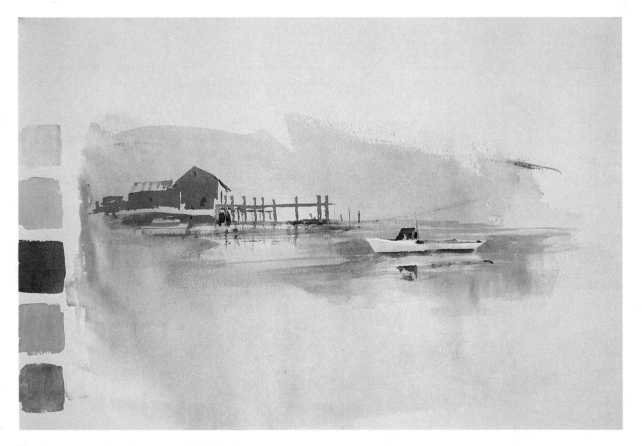

Evening. Watercolor demo on 140 lb. block, 14 x 20″ (36 x 51 cm). Collection of the artist.

This small watercolor demo was executed in approximately forty-five minutes, using an upright easel. There is a definite advantage to painting with your paper in an upright position. Gravity comes into play and the water flows down the sheet rather than into it. As a result the washes drip a little, but they also dry faster. The disadvantages are that you don't get as much color saturation as you do when the sheet is lying flat or at a slight angle. My palette for this piece was Thalo blue, new gamboge, and Winsor red. The swatches on the left show you the sequence of the washes.

HOW LONG DOES GLAZING TAKE?

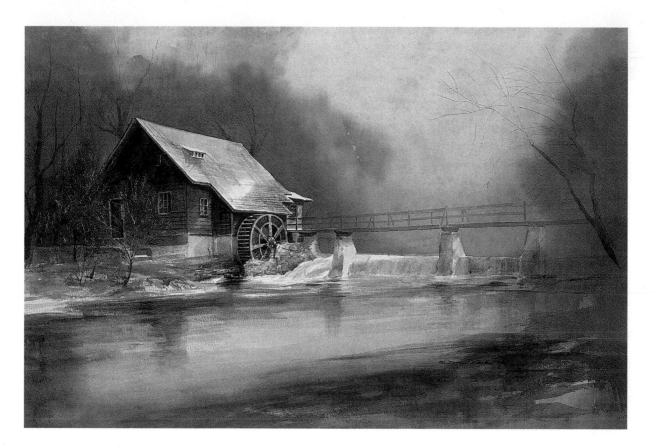

Downstream. Watercolor on 140 lb. D'Arches paper, 17½ x 28″ (45 x 71 cm). Collection of the artist.

The execution time on this piece was about two and a half days: one day for foundation washes, one day for modifying color, and half a day for final details and minor adjustments. This painting is much larger and more complex than the previous one. As you compare the two works, you can see that this one is a bit more complicated in its composition and lighting. The more complex, the more layers can be involved.

The palette for this watercolor consisted of new gamboge, Thalo blue, Winsor red, Thalo yellow-green, and manganese blue. The sky is predominantly new gamboge with a small amount of manganese blue in the under wash. If you look carefully, you will see it peeking out in the sky. The background trees are combination washes of new gamboge, new gamboge with Thalo yellow-green, and new gamboge with Winsor red. In the final wash, the red becomes a brown.

Much of this color was brought down into the stream. In the highlight areas of the water, the wash was not allowed to concentrate and build strength, except where it was used for reflection as in the extreme right corner.

For the final stages, I washed a mixture of Thalo blue, manganese blue, and new gamboge into the water area. To create the waterfalls, I dry-brushed the water wash. The roof of the mill is a combination of manganese blue, new gamboge, and Winsor red. A lot of this color was also incorporated in the foundation and later modified with Thalo blue and used in the dam under the bridge. The siding of the mill is a mixture of Winsor red, Thalo blue, and a small amount of new gamboge. This same wash was used in varying strengths on the footbridge. The final passages were the areas where the darkest washes now appear: a mixture of Winsor red and Thalo blue.

16

Q: Sometimes I have trouble making the colors in my painting harmonize; it looks like two separate watercolors. Can glazing help?

A feeling of discord in a painting can be a composition problem or a color problem. Composition is a separate topic that I'm not going to address here. But glazing can definitely help establish color harmony, because when glazing you often have to rely on the primary (or near-primary) colors to create other hues and variations. The fact that you are creating your range of color from a common source creates an overall harmony and aids your color balance.

Some beginning painters will pick out five or six tube colors—say, a blue for the sky, a green for the trees, a brown for the earth, and so on. This seems harmless enough, but it can lead to a very inharmonious painting since none of the colors really go together.

Another common problem is that painters often try to mix their own colors by relying on the names printed on the watercolor tubes, without analyzing the more specific color makeup of that particular hue. For example, nearly everyone knows that red and blue make violet . . . or do they? The truth is that pure red and pure blue make violet. In graphic production terms we would say that magenta and cyan make violet. But when you buy

watercolors, there are dozens of reds and blues to choose from, and not all of them will interact like pure primaries on your palette. In fact, the limitations of pigments sometimes make *true* primaries impossible; we have to make due with approximations.

Try an experiment. Mix vermilion and ultramarine blue; is the result violet? Mix vermilion and Thalo blue; are the results any better? Now switch reds and substitute Winsor red for vermilion. Are the results any more pleasing? Why are the mixtures so different?

Vermilion contains quite a lot of yellow, while Winsor red comes much closer to the primary magenta. The amount of yellow in these two reds has a major effect on how each of them mixes with blue to create a new color.

It take years of practice to master all the intricacies of mixing colors, but even a beginner can learn fast. Get a color chart and memorize what magenta, cyan, and yellow look like. When you select colors on your palette, mentally compare them to the primary colors. The more closely you approximate those primaries, the closer you will come to getting the expected results.

A: Glazing can help you achieve color harmony, since most of the time you will be mixing and overlapping a few colors to create a range of hues. Eventually an instinct for color will become second nature.

vermilion + ultramarine blue = brownish violet
(slightly opaque)

vermilion + Thalo blue = brown
(fairly opaque)

Winsor red + ultramarine blue = purple
(slightly opaque)

Winsor red + Thalo blue = deep purple
(fairly transparent)

Above you see four mixtures of tube colors that
produce violet. The next page shows six examples
of other color tube mixtures.

Indian yellow or new gamboge + ultramarine blue = olive (slightly opaque because of ultramarine)

Indian yellow or new gamboge + Thalo blue = bright green (very transparent)

Indian yellow or new gamboge + cerulean = pea green (slightly opaque)

Indian yellow or new gamboge + manganese blue = light green (fairly transparent)

Indian yellow or new gamboge + vermilion = orange (fairly transparent)

Indian yellow + Winsor red = red-orange (fairly transparent)

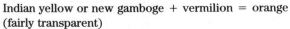

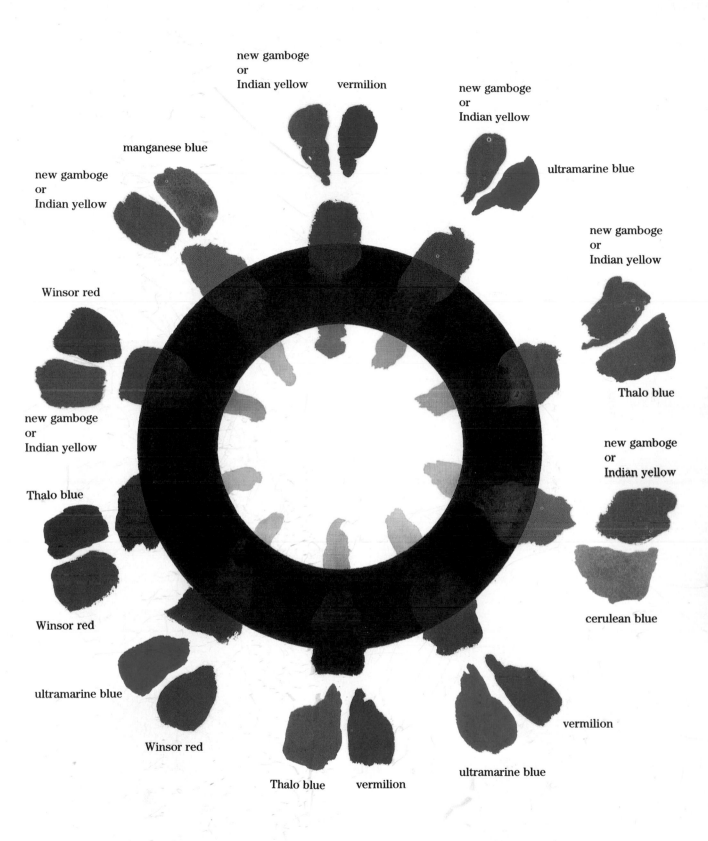

new gamboge
or
Indian yellow

vermilion

new gamboge
or
Indian yellow

manganese blue

ultramarine blue

new gamboge
or
Indian yellow

new gamboge
or
Indian yellow

Winsor red

Thalo blue

new gamboge
or
Indian yellow

new gamboge
or
Indian yellow

Thalo blue

cerulean blue

Winsor red

vermilion

ultramarine blue

ultramarine blue

Winsor red

Thalo blue

vermilion

To determine the opacity and transparency for each of the color combinations previously mentioned, I first painted a circle with black India ink. Then I applied graded washes of each color mixture, painting toward the circle's center.

Try this test yourself. Remember, it is one thing to look at my samples and quite another to do your own. You must get the feel of these washes; merely looking at the pages of this book won't do the trick.

Q: Do you ever use any other colors besides red, blue, and yellow?

A: I use other colors only if a hue is difficult to produce by mixing the primary colors, such as Winsor violet, cadmium orange, Thalo yellow-green, Hooker's green, and sap green.

At times I do use other colors such as Winsor violet, cadmium orange, Thalo yellow-green, and an occasional Hooker's or sap green. But for the most part, I find that the primary colors offer such a wide range of mixing possibilities that I do not need to buy premixed colors.

I often use additional colors if they are difficult to create from mixing primaries. For instance, the tube varieties of violet and orange are especially difficult to approximate.

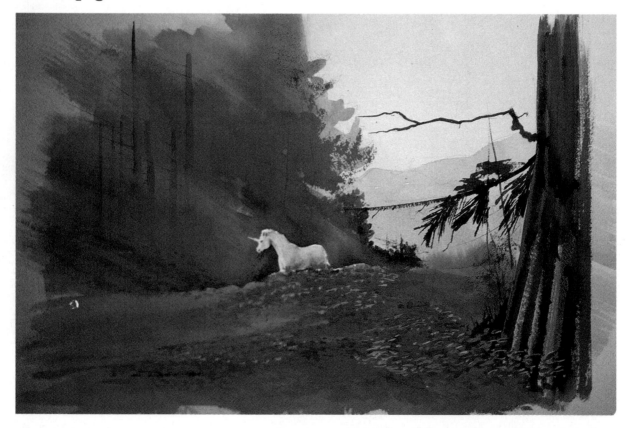

Unicorn. Watercolor on 140 lb. D'Arches cold-pressed paper, 11 x 14″ (28 x 36 cm). Private collection.

The palette for this little watercolor consists of Winsor violet, Thalo yellow-green, Hooker's green dark, indigo, Thalo blue, vermilion, cerulean blue, manganese blue, and new gamboge. To add a color contrast in the background, I applied a pale wash of Winsor violet over a portion of the sky—which is a mixture of Thalo blue and manganese blue—to create the mountain range. In the foreground, I created depth by applying a base wash of Thalo yellow-green and painting the leaf shadows with Thalo blue and new gamboge. To add diversity to the trees, I used Hooker's green dark and vermilion to create darker trees. The shadows on the tree trunk are vermilion and Thalo blue with some Thalo yellow-green. The shadow values on the unicorn are Thalo and cerulean blue.

18

Q: Should every area of the painting be built up with layers of wash?

A: It depends on the effects you want to achieve. You can cover the entire painting surface with glazes, or work in specific areas to create contrasts.

The advantage of using the glazing technique is that you can use it as much or as little as you like. There are no rigid rules. You are free to adapt the approach to create whatever kind of effect you want to produce. In many cases, I will only glaze the foreground and paint the sky in one wash. At other times, I will glaze everything. It all depends on the need of the painting. For instance, you can achieve some powerful contrasting light effects by juxtaposing glazed areas against unglazed sections of a painting.

Every once in a while you find a rare treasure. This beehive was one of those exceptions. A student working as a tree surgeon brought me this rarity. It has inspired many studies and conversations. In this painting, I made use of glazed and unglazed areas in the same piece. For the entire nest area, I applied a very dilute wash of new gamboge. In the highlighted areas, this was the only wash used. The shadows were built up with several layers of Winsor red, Thalo blue, and new gamboge. The dark areas of the comb are darker washes of the same color mixture.

The limbs and small twigs were painted in a rather direct manner over some minor prewashing in the shadow areas. Much of the limb texture is the result of dragging a partial dry brush over the surface of the dry paper. In this work, I was trying to capture the delicate nature of the color in the wild honeycomb. Some of the values are quite elusive and difficult to approximate. I found that too many layers of color would make the hue too powerful. Therefore, I used light preliminary washes to capture highlight color, and then I increased color strength by glazing the shadows.

The City. Watercolor on 140 lb. D'Arches cold-pressed paper, 13½ x 19″ (34 x 48 cm). Collection of the artist.

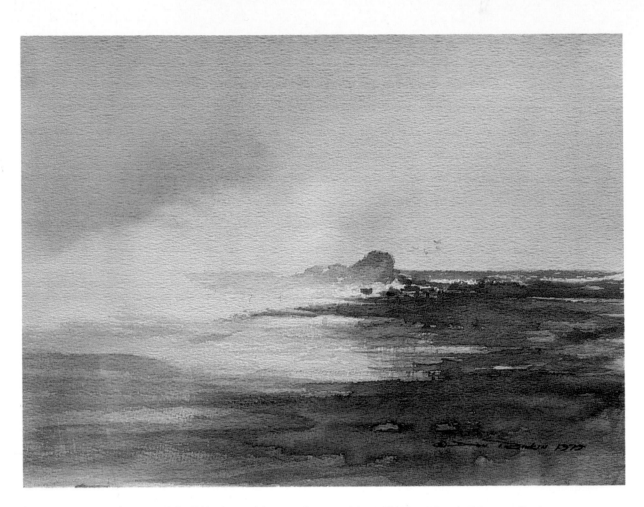

Seascape. Watercolor on 140 lb. D'Arches cold-pressed paper, 11 x 14″ (28 x 36 cm). Private collection.

This little watercolor contains an almost equal balance of glazed and unglazed areas. First I applied the sky wash, using a mixture of Thalo blue, vermilion, and manganese blue. The white mist, foam around the rocks, and the light on the beach—the main unglazed areas—began to develop as I was working on the sky. Next I set the horizon line on the right side of the painting. Using a mixture of Thalo blue and new gamboge, I created a warm green. This color was brought about halfway down into the foreground and allowed to bleed out to a nondescript edge. This color was a little shocking compared to the paleness of everything else but at least it gave me a value to start with.

While this was drying, I very carefully dampened the left side of the sky. There was a hint of the mist hanging in the sky, which I wanted to intensify. Using Thalo blue and vermilion, I began painting in behind the veil of mist with the point of my series 7, no. 6, red sable brush. By touching the tip of my brush to the wet paper with a stabbing motion, I gradually added color to the wash

without disturbing it. Then I produced a warm neutral gray by mixing new gamboge, vermilion, and Thalo blue, and used it to work the foreground area in a wavelike manner with a large flat brush. As I reached the bottom of the sheet, I let the brush drag in a dry-brush manner to create the texture in the foreground.

While this was drying, I mixed up a dilute wash of the green I had used earlier. Then after the sheet was dry, I began to overlap this color in the middle and foreground again, taking care to avoid the natural white of the paper in the foam area. Now the rocks in the mist and foam were ready to be included. Using a blue-gray made of vermilion and Thalo blue, I carefully brushed in the main rock. Much of the texture created in the foreground is the result of dry-brushing the darker greens and the warm grays to build up texture. The play between the darker, more heavily glazed sections and the lighter sections, where no glaze was used, helps to create a harmonious balance and a strong but somewhat understated contrast, which enhances the composition of the painting.

19

Q: Does my paper really have to be dry before I apply another layer of wash?

Yes. This is one of the few hard and fast rules that you must observe. Each layer of wash must have time to dry to allow the binder to adhere the color to the sheet. If you try to rush this process, you will only stir up or disturb the damp paint, preventing it from adhering to the paper. If you continue to disturb the wash, the color will become tired, muddy, and have an overworked look. But if you allow each layer of color to dry completely before the next wash is applied, your washes will be vibrant and crisp. When a wash is dry, the next layer of color will help boost or amplify the previous layer. The resulting glow makes all of the extra time and effort worthwhile.

However, it is very important that you understand about the level of moisture apparent on a sheet when each succeeding wash is applied. For example, when a sheet is very damp it is possible to introduce another wash. After all, this is the basis for working in a wet-on-wet technique. Therefore, a good rule of thumb is that when there is a lot of water, it is safe to work the sheet. When the water volume diminishes, say in the latter drying stages when it is visibly apparent that the sheet is barely moist, it becomes risky to add any new moisture. From this state until the sheet is bone dry, the wash on the paper is very vulnerable to additional moisture. New moisture will wash the color right off the sheet at the worst or muddy the overall look.

There may also be times when you may want to break the rule to create a special effect, such as a slight touch of opacity in a certain wash. Be advised that this is an approach that you need to consider before using because it is risky. When you depart from the rule, you run the risk of getting a muddy look. But at times, in small patches of the work, this look can be effective.

The following are some examples of what happens when you don't allow the washes to dry before adding another layer. In all of the samples, the same washes were used. In fact, all of the samples were painted on the same sheet of paper. Every sample was painted as it would have been had it been in an actual painting sequence. I made every effort to keep the results objective.

A: If you want your washes to be vibrant, crisp, and clear, then you must be sure that your paper is dry before you apply another layer of color.

Compare the sample on the immediate right with the one on the top of page 57. Both used a pale background wash of vermilion and Thalo blue followed by a dark mixture of Thalo blue, vermilion, and indigo. In the first sample I added the second wash when the first was almost dry—and within thirty seconds the blotch was apparent. In the second sample I had much better control because the first wash was fully dry before I applied the second. This time the result was a clean, vibrant glow. It looks as if there is a stand of trees behind a mist, with some individual trees distinguishable.

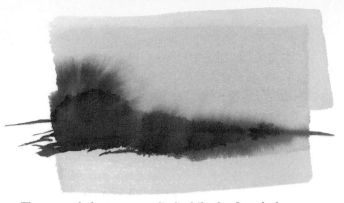

The second glaze was applied while the first dark glaze was still damp.

Here, I applied a wash of new gamboge. When it was nearly dry—it looked dry but was cool to the touch—I applied a wash of vermilion. This sample was then left to dry. Look at the irregular tonality in the wash. Since the sheet was already damp, the new wash added even more water. Thus, the additional water disturbed the new gamboge that was drying. As a result, some of the color was lifted. If you scan the entire wash block, you will notice that the center looks as though much of the new gamboge has been diluted. At the top, the color is stronger. The reason for this is that the paper was drier at the top than it was in the center. The result is a messy passage of color.

damp

In this instance, the paper received three layers of wash. With each layer, the process was rushed and the paper was not quite dry. The resulting build up of pigment and water created an uneven tone and a classic "explosion" at the bottom of the color passage. The first layer was new gamboge followed by two layers of vermilion. I allowed some drying time between each application, but the paper was still mildly moist. The accumulation of water and damp pigment created the results you see here.

damp

MUST I LET PAPER DRY BETWEEN WASHES?

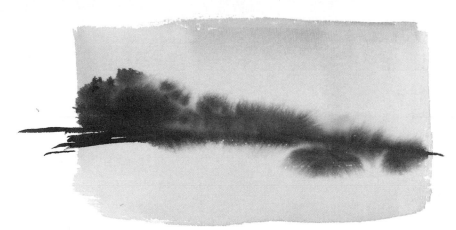

Paper allowed to dry between washes.

dry

When each layer of wash is allowed to dry, the result is a clean, vibrant wash that appears to glow. Compare this color block with the opposite one. The difference in color quality and tonal uniformity is evident.

dry

This final example is how a layered wash should look. There are three layers; the first is new gamboge, the next two are vermilion. Each wash was allowed to dry completely before the next one was applied. The results are amplified color and a clean, crisp, uniform wash.

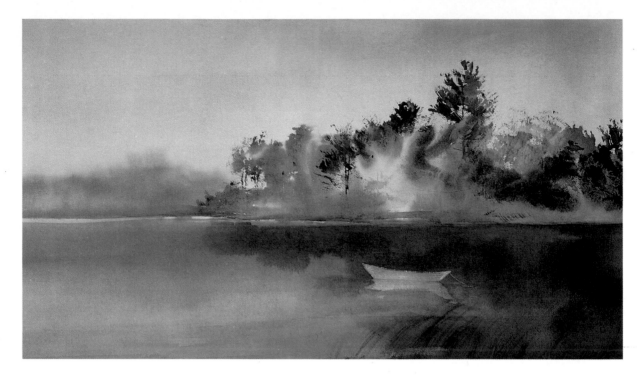

White Dory. Watercolor and India ink on 140 lb. D'Arches paper, 26 x 42" (66 x 107 cm).
Collection of Shihan Y. Oyama.

This painting is a mixture of black India ink and watercolor. The key here is that the ink I used isn't water-soluble. I also chose paints that were very transparent, even in their more concentrated solutions. The colors in this piece look fresh and vibrant even though they are subdued. I first applied the ink mixture for the light gray washes in the trees and the dark reflections in the water, using the wet-on-wet technique. The key to success with this technique is the selective dampening of the paper. The ink will spread and swirl very quickly wherever it finds wet paper, so I dampened very carefully around the boat and made sure the tree line was good and wet.

After this stage was dry, it was time to apply color. My palette consisted of Thalo blue, indigo, Winsor violet, Winsor red, and of course black India ink. I dampened the entire sheet, and then I flooded a mixture of Thalo blue and Winsor red across the whole sheet. Almost the entire sheet received this wash, except for a few bright spots in the tree line and the stern of the dory itself. Once this wash was dry, I dampened the sky portion of the painting. Then I dampened the water portion, leaving a thin band of dry area between the two. This would become my shoreline. To this dampened sheet, I applied a wash made up of

Winsor violet, Thalo blue, and Winsor red. This was used for the distant tree line; a dilute version of this wash was also used for the hint of reflection in the water.

When the sheet dried, I dampened the sky once more. Next I wanted to work on the middle values of the large dominant tree line across from the dory. The wash was a mixture of Thalo blue and indigo. A great deal of this color overlapped some of the earlier gray tones of the India ink. The resulting color was a variation between gray and blue, depending upon the strength of the under wash. As you look at the illustration, you can see how the color changes subtly from one area of the tree line to another. The stage was set for this variation when the initial ink wash was applied.

After this application had dried, I set about to add the darkest values. For this application, a strong mixture of Thalo blue and indigo was used. The washes were placed in proper position so that they appeared to blend with the previous wet-on-wet wash. While all of this area was being refined and modified, I was also working the area around the dory in the foreground. Winsor violet, Thalo blue, and indigo were used in strong solution in this area. In the final stages, I used an X-Acto knife to scrape thin detail lines in the dory.

20

Q: Can I use a hair dryer to speed up the drying process between layers of wash?

A: I don't recommend using a hair dryer on good-quality paper, because it will most likely damage the surface. If you must use a hair dryer, select a low or medium setting and keep the nozzle several inches away from the surface of the paper.

I don't like hair dryers because they can ruin the surface of the paper. When you invest a great deal of money on a quality sheet of paper, you don't want to expose that fine sheet to an unrelenting blast of hot air. If you look under a microscope at a sheet of paper that has been exposed to hot air, you will see thousands of little frizzy fibers that have been loosened by the heat. This condition will affect the quality of your work. Granted, some of the less expensive, commercial-grade sheets will take this treatment without quite as much alteration. But even so the hair dryer can be brutal. If you have to use one, and on occasion I have used them to speed up the drying process when I am glazing, use it with care. Select a medium or low setting and keep the nozzle several inches away from the surface of the sheet. Keep moving the dryer so that heat is not concentrated in just one spot for more than a few seconds. In this manner, you can protect the surface of your paper.

This color block was painted on a piece of 400 lb. D'Arches rough watercolor paper. Before applying a wash, I dampened the paper in one section several times and repeatedly dried the same area with a hot hair dryer. (I could already see the difference between the damaged and undamaged areas, but it would have been quite difficult to photograph at this stage.) Next I painted a layer of wash over the damaged section, positioning the wash so that part of it was over an undamaged area as well. I really didn't expect to get the dramatic result shown here.

I fully expected a difference in textural appearance on the sheet. I didn't expect the damaged side to appear darker. If you look at the block, you can see a horizontal line of division. The portion on the top was subjected to several drying sessions with the hair dryer. The lighter portion on the bottom was never dampened until the blue wash was applied. The portion on the top that had been dampened and dried also had a change in surface texture. When I viewed it from an angle with powerful light striking obliquely across the sheet, I could see that the surface of the paper was raised much like the welt of a scar. As a result, the surface of the paper in the dried area had "opened" up. This allowed more pigment to seep

hair dryer used on this side

this side naturally dried

in, making that section of the paper appear darker. On the actual sample, the wash has a grainy appearance in several places. Since this was a clean wash of diluted Thalo blue, I know that a grainy appearance is not characteristic of this paint, but of a damaged piece of paper.

21

Q: What happens if I apply my darkest washes first?

A: You may create muddy colors if you are an inexperienced painter. However, you can avoid some of this if you use transparent staining colors.

Unless you know how to handle washes properly, you'll produce dull, muddy passages of color. However, this doesn't always have to be the case. When you first begin to paint, it is more likely to happen because you haven't developed enough experience. You must use a light touch and work fast in this method. Essentially, the application of a lighter value of wash over a darker value creates a misty veil that slightly obscures the passage of light as it bounces off the paper, producing a slightly opaque or cloudy appearance. This effect is far greater if a more opaque color is used over a darker passage. If you are using the more transparent staining colors such as Thalo blue or new gamboge, you can layer these over one another without as much of a noticeable effect. (Staining colors don't lie on the surface of the paper, where they can be picked up or disturbed.) However, if you apply one of the cadmium yellows or cadmium red deep over an ultramarine or cerulean blue, you will get a pronounced opaque effect. Just remember the more transparent the wash, the more forgiving it will be if you bend the rules. You might want to review Question 10, which deals with the relative transparency and opacity of colors.

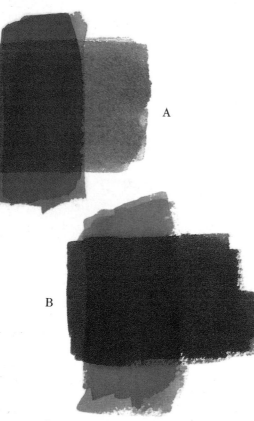

A

B

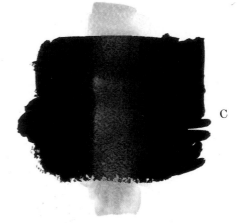

C

These two color swatches show what you can usually expect when you apply a lighter wash over a darker field. In sample A, two washes of new gamboge were layered over a wash of Thalo blue and indigo. For sample B, two layers of new gamboge were layered over a mixture of vermilion, Thalo blue, and new gamboge. As you examine the two samples, you can see that the washes have become dull and dirty. The color resulting from the layering is not very vibrant either. Inexperienced painters often produce muddy colors like these by glazing light over dark.

In this final sample, I used black India ink to emphasize the background. Across this dark field I applied a thin wash of cerulean blue. If you look closely at this diluted wash, you can see that it appears to float against the darker background, creating a special effect. In very dark contrasting situations, you can use cerulean blue to create the effect of smoke or sunlight filtering into a room. In areas where the contrast is not as great, you can use ultramarine blue for the same effects. This is an instance of deliberately glazing light over dark for a special reason.

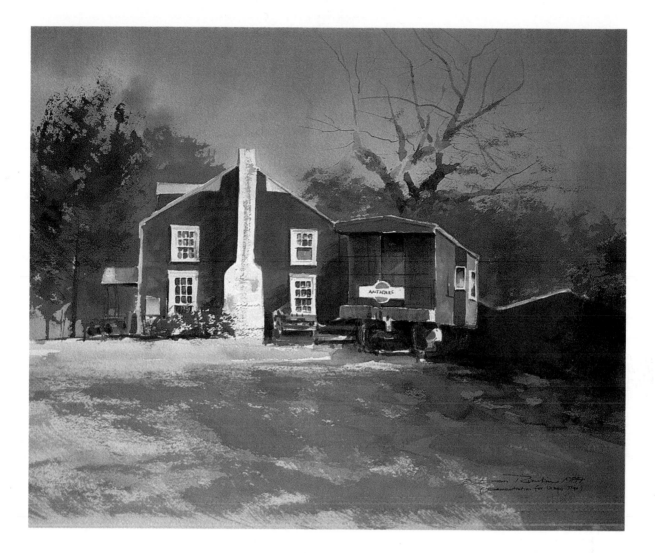

The Antique Shop. Watercolor on 140 lb. D'Arches paper, 17½ x 24″ (45 x 61 cm).
Collection of the artist.

To produce this painting, I used alternating washes. For the first two or three washes, I applied new gamboge to everything except the white trim of the buildings. For the sky, the paper was dampened before each application. In the foreground, the wash was applied in a dry-brush manner to create a grassy texture. After the sky washes were dry, I made a mixture of new gamboge, vermilion, and a touch of Thalo blue to create the background trees. In some areas, more than one wash was used to intensify the color. The washes of red in the house, barn, and caboose consist of Winsor red, vermilion, and Grumbacher red. The darkest tree values were a mixture of Thalo blue, new gamboge, and vermilion. Note that the trees are nothing but simple brushstrokes.

While evaluating my progress, I felt that the trees on the left appeared to be too stark for this stage. There were no other hints of tree trunks on this side. Being fully aware of the rules, I instinctively elected to come back into this area with a lighter color value. When the dark of the trees was fully dry, I mixed up a wash of new gamboge, Winsor red, and a little Thalo blue (all three colors possess some staining power). I bathed the entire left side of the tree area with this color, using a large square-edge brush. As I approached the horizon, I used the side of the brush to define the tree trunks. While this was drying, I took a sable brush to clean up any rough edges where the tree line meets the shop. As the wash dried, I could see that my gamble had paid off. The effect of glazing light colors over dark worked and added greatly to the painting. The rest of the painting was completed in the normal dark over light manner.

Q: Why do some of my washes look chalky when they dry?

A: Most times, a chalky effect is produced when you apply a light wash over a dark one. However, in glazing, there are certain floating pigments that naturally contribute to this effect.

This question is related to the preceding question. In many cases, you will get a "chalky" effect just by applying a lighter color over a darker passage. However, in the glazing technique, you can get the chalky effect just by glazing certain colors. For example, cerulean blue, cadmium yellow, cadmium red deep, Thalo yellow-green, and others have a tendency to contribute to this effect in normal use. Cobalt blue and French ultramarine blue have a tendency to cause this effect although for the most part they retain their color while doing it. Most of these colors are what I often refer to as "floaters," which means that they lie on the surface of the sheet and do not sink in and stain the paper. This means that they tend to rise up from the surface of the paper after other washes are applied over them. For the most part, they will also retain their color identity. In most cases, you might think of this as a detriment to good painting. However, the nature of these colors can help you to create some interesting atmospheric effects.

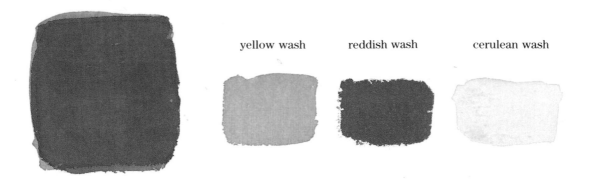

yellow wash reddish wash cerulean wash

The three values of wash (yellow, red, and cerulean blue) were applied to the large color block. Notice that the final wash of cerulean blue is very weak. However, even this pale wash placed over the darker ground has created a cloudy, chalky appearance to the overall color. The darker the underlayer, the chalkier the appearance. Remember, this occurs because the top wash is a "floater." That is, the pigment tends to float on the surface of the paper rather than stain it. This floating action creates a film on the top layer that obscures the transmission of light, creating a chalky look.

Try similar color tests for yourself. In that way, you will be able to see the effect firsthand. Having a thorough understanding of the nature of the colors that you use will be most helpful as you plan your sequences.

23

Q: Sometimes my dried wash seems to be scrubbed up and uneven. Why is this happening?

There are several possible contributing factors that may cause this problem. If you use a medium or large bristle brush in your work, you may be scuffing the paper with it. When the paper is damp, it is vulnerable to abrasion and pressure. The bristles can literally cut the surface of the paper, creating a rough texture that will take color unevenly. So whenever you use a bristle brush on damp paper, use a light touch. Let your brush (sable or bristle) glide across the surface; that way you won't disturb any previous washes.

Another factor may be that you are applying washes before the surface of the paper is completely dry. Gently touch the corners of your paper with the back of your hand. If the surface looks dry but feels cool, give it a little more time. With practice you'll get the hang of it.

The third possibility, and one that occurs more often than you think, is contaminated paper. Make sure that your paper is kept in a cool, dry place away from chemicals and dust. The oils in the human hand are not good for the paper either. Too much handling can leave small splotches of oil that may disrupt the color coverage.

It is also possible that you are attempting to use a paper that just can't stand up to the wetting and rewetting cycle often required in the glazing technique—many student-grade sheets and watercolor boards fall into this category. Choose your papers carefully to avoid frustration later.

A: Some elements that can contribute to this problem include dragging medium or large bristle brushes across the surface of the paper, applying washes before the paper is completely dry, and using contaminated or low-grade watercolor papers and boards.

A scrubbed with a bristle brush

This color block was dampened with clear water before any wash was applied. Once the square was dampened, I scrubbed a bristle brush across the surface, marring the finish of the paper. When paper is damp, it is very sensitive to pressure or abrasion. The inverted "U" shape is the area where I dragged the bristle brush across the paper with a little more force than was necessary. Develop a light touch to prevent this problem.

Notice the splotches in this color block; they appeared because the color did not take evenly on the surface. This edge of the paper had been left exposed to the open air in my studio for about three months. During this period of time, this portion of the sheet has been exposed to dust, insecticide spray, and human hands. While there are some manufacturing flaws that can cause a similar problem, I believe that contamination is the culprit here. This splotchy condition only occurred on this exposed portion of the sheet.

B splotchy

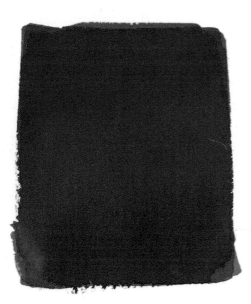

Here, you see an uneven wash. The first layer was allowed to dry, but the second wash was not quite dry when the third wash was applied. As a result, a portion of the second layer was swept away when the third wash was applied. You can easily prevent this by making sure your paper is dry. Learn to touch it with the back of your hand. Remember that if the paper is cool to the touch, it is still damp even if it looks dry. Your eyes can deceive you.

C uneven

24

Q: Occasionally my washes look grainy or dirty. I think I am following the proper procedure; what could be causing this?

A: Watercolors left uncovered on your palette in between painting sessions will collect dust and produce dirty washes. Also, combinations of two or more mineral pigments such as ochres, siennas, umbers, ultramarine blue, and cobalt blue create sedimentation, which produces a grainy texture.

First let me clarify what I mean by "grainy or dirty." Unlike chalky colors, which look whitish and slightly opaque, grainy colors contain dust specks or gritty sediment deposits.

Rule number one, make sure your palette is clean. If your palette is left open to dry out in your studio, it will be collecting all kinds of household dust and debris that will get into your wash. Allowing tube color to dry on your palette is not a good habit; tube colors need to be kept moist, so put a lid on your palette. If mold starts to grow, dampen a piece of paper toweling with any liquid disinfectant and place it over the palette, then close the lid. The disinfectant will inhibit the mold growth.

Another probable cause of graininess is "sedimentation," which occurs when you combine two or more earth tones together to make a wash. For example, raw sienna and ultramarine blue make some lovely earth gray shades, but they also create a great deal of sediment. When this combination or others are mixed, the result is a sandy, grainy look. This can be great for creating certain textures, but you would definitely be upset if this condition appeared in your skies.

If you look closely at this ultramarine blue color block, you can see that it is naturally grainy. It is made from ground mineral pigment, which tends to float on the surface of watercolor paper.

This cool gray is a mixture of equal parts of burnt sienna and ultramarine blue. Because both colors are mineral pigments, when combined in a wash, they form a grainy effect called sedimentation.

Here you see a color block that contains two layers of color. The first layer is a cool mixture of Thalo blue and new gamboge. The second wash is ultramarine blue, and the result is a grainy texture.

This color block has the same cool blue base as the previous sample. The final wash is a mixture of ultramarine blue and cadmium red deep. This surface is also grainy.

Q: There are times when I get harsh, abrupt edges while trying to build up layers of wash. How can I avoid this?

A: Make sure you dampen your paper before applying the initial wash. You can also feather the edge of a lighter wash at the point where a darker wash will be applied later.

Unfortunately, unwanted harsh edges are among the main obstacles that you must overcome to master the glazing technique. Thankfully, much of this can be prevented by proper planning, and using the correct technique.

Most of the time, harsh edges occur when you are trying to butt two color planes against one another. For example, where the sky meets the horizon, a mountain range, a tree line or a rooftop, or where water meets land.

To make better transitions, you can feather the edge of the paler or lighter wash in the area where the other darker color will meet it. After the wash or series of wash dries, you can apply the darker wash. The darker wash will cover the feathered edge of the lighter wash and no seam or abrupt edge will show.

Don't give unwanted harsh edges a chance to build up. Unless you like the rugged look, make sure you dampen your paper before you apply the initial wash.

This is a typical direct wash. I applied pigment directly onto dry paper. All of the edges are crisp.

In this wet-on-wet example, the color is delicate and all the edges are soft. This will make it easier for me to blend and overlap colors for a smooth transition. Another approach would be to use a modified wash that looks similar to a graded wash.

This wash can be blended on its softer edge with other washes. You can "feather" a soft edge with clear water.

Three washes of the same color and the same strength were used to produce this example. You can see a few hard edges in this color block. These occur because it is not possible to paint over the same area time after time with absolute precision. Don't try to fight the consequence of not being a perfect machine. Work around it.

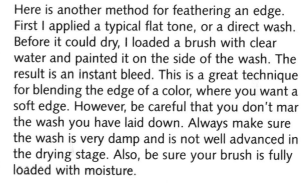

Here is another method for feathering an edge. First I applied a typical flat tone, or a direct wash. Before it could dry, I loaded a brush with clear water and painted it on the side of the wash. The result is an instant bleed. This is a great technique for blending the edge of a color, where you want a soft edge. However, be careful that you don't mar the wash you have laid down. Always make sure the wash is very damp and is not well advanced in the drying stage. Also, be sure your brush is fully loaded with moisture.

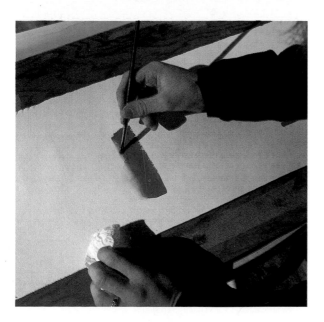

After the wash was dry, I used a damp bristle brush to soften the hard edge on the wash. I can also scrub or scrape the offending edge out.

I made a typical flat tone by pulling my brush back and forth over an area using horizontal strokes. With the brush, I literally pushed a puddle of wash across the paper. When the brush reached the lowest point, the moisture was also there in the form of a small puddle. This puddle had to be soaked up, otherwise the result would have looked like one of the four examples to the right: (1.) The wash left at the bottom discolored the tone. (2.) The wash is streaked as well as uneven. (3.) Not only is the wash uneven in tone value but a small "explosion" is evident in the lower right corner. (4.) Here, as the wash was drying, the excess moisture was drawn into the drying area, creating a streaked, uneven wash.

flat-tone wash

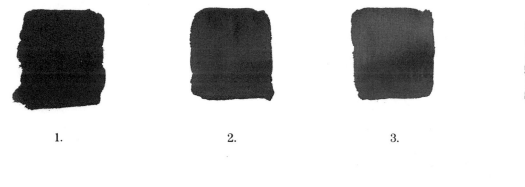

1.

2.

3.

4.

To avoid uneven, streaked edges, you should have a tissue handy when you have completed your wash. Touch your brush first to the area to be soaked up, then to the tissue to remove the excess moisture from your paper.

Take your brush and lightly apply the tip to the puddle of wash. Your damp brush will act like a sponge and draw the moisture up. If the puddle is fairly large, you may need to do this more than once. In cases where the puddle is really big, use the corner of a tissue instead of a brush. Be careful not to disturb the color.

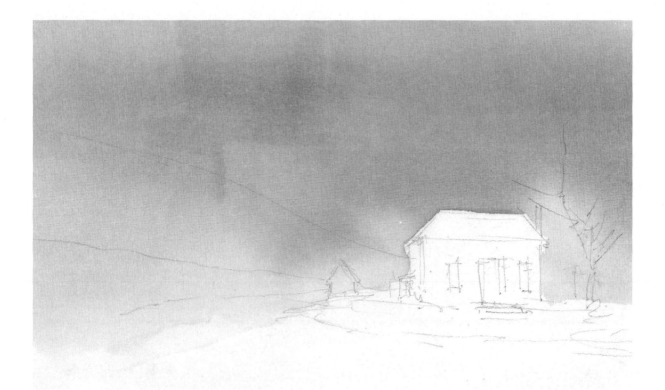

My first wash covers the sky and comes down below the horizon line. I did not stop at the horizon line because it would have been impossible for me to match another wash perfectly. If washes don't match, an unwanted edge is going to form.

I resolved this problem by painting well below the horizon line and feathering the wash until it blurred into near oblivion. In order to do this, you must make sure your water and brush are clean. The object is to develop a wash that can be covered effectively by the next wash without harsh edges showing through.

Where the sky meets the horizon—whether the horizon is a mountain range or the sea—there is a chance for an unwanted harsh edge to appear. If you obey the rule of feathering the lighter wash, everything will work just fine. This sample contains two washes, and I have kept everything very transparent so you can see both layers. The first layer is the sky. After the paper was dry, I applied the second darker wash. It covers most of the first wash and defines the mountain range. I allowed some of the lighter wash to peek through in the foreground for variation.

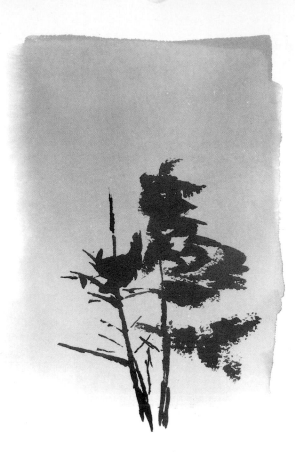

Tree lines can also pose a problem. In this sample, I put down the sky wash first. When it was dry, I put in the tree line. If you want to have bright autumn foliage on your trees, the same principle applies. You must put in the lightest wash, feather the edges, and cover it with the darker wash.

Architectural or other manmade elements can be handled a little differently. I can usually butt a color up to the edge of a structure because it isn't easily plagued by hard edges. But if the structure is complicated and the color arrangement will allow, feather the sky into the structure, reserving only those areas that must be kept lighter in value. This will help you avoid any unwanted harsh edges.

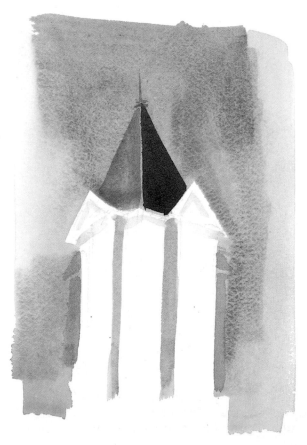

AVOIDING HARSH, ABRUPT EDGES

26

Q: You often mention wetting the paper before you begin to paint. Do you ever paint layers of wash directly upon dry paper?

A: Although I usually work on wet paper, I also paint washes onto dry paper, especially for relatively small, simple paintings.

Absolutely. Each method has its uses. The main reason I wet the paper is to help enhance the flow of large areas of wash. A dampened sheet allows you to cover a lot of area without much effort or pressure. In the beginning stages, this is especially helpful because you can get a great deal accomplished with less risk of disturbing the underlayers of color. Also, a damp sheet gives you more time to manipulate and make adjustments to the wash— much like light preliminary lines in a drawing, which can be adjusted as the image gradually becomes more definite.

However, the direct method (washes on dry paper) is useful too, especially for small watercolors that contain bold shapes. Working on dry paper is usually faster, but I don't recommend it for intricate detail or complex patterns, which often require more finesse than a single brushstroke.

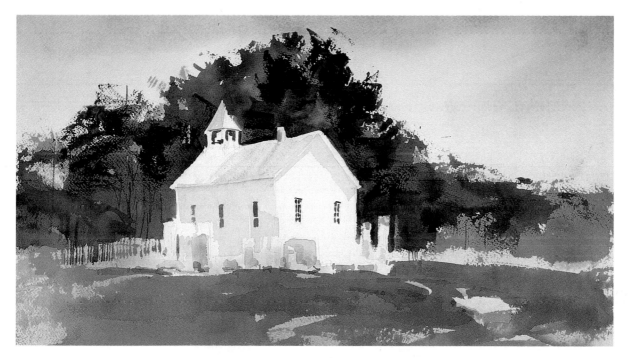

In this watercolor, the white of the clapboard church is the white of the paper, and both the sky and the foreground were painted directly onto dry paper.

I began with a pale wash of Thalo blue and manganese blue for the sky, applied directly at the top but diluted with water as it was pulled down the sheet. The next direct wash, composed of a pale tone of new gamboge with a slight hint of Thalo yellow-green, was applied to the horizon line and areas of the foreground. The broad washes around the tombstones were also applied

directly, and the large shadow areas are the result of using a large square-edged brush. As you can see from the brushmarks, I waited for each layer to dry before applying another wash.

This is a prime example of glazing with direct washes. One of the characteristics of this approach is a more painterly look. I was able to get the value of layers of color as well as a spontaneous, direct brushwork. The composition is simple, with large interlocking shapes and very little wet-on-wet work or feathering. Such compositions are ideal for a direct approach to glazing.

Q: How do you know when to wet the paper and when to paint directly on dry paper?

A: It all depends on the effects you want to achieve. Wet paper would be best suited for a soft, atmospheric look with blended edges, whereas dry paper would be better for a rough, rugged effect.

In painting I think everything should be done for a reason. The decision to paint on wet or dry paper depends entirely upon the effect you are trying to achieve. Do you want a soft atmospheric look to a certain area or to your whole painting? If so, you will find that the wet approach works best for this effect. Here's why. When you apply a wash to dry paper there is less room for second chances or for blending edges. This is not to say that it can't be done, for it can, but a dry sheet will cut down your time for manipulations and corrections. The damp sheet makes some of the decisions a little easier because you have a larger margin of time to make adjustments or color corrections before the passage dries and locks you into a specific course. While the paper is drying, you have time to look for ragged edges and little imperfections that you can correct while the sheet is still damp.

On the other hand, if you want a rugged effect with sharp contrasts, you would be better off painting on dry paper. When working on dry paper, you can also incorporate the texture of rough or cold-pressed paper to suggest details—it can become an integral element of your composition.

Color swatches painted directly onto dry paper, as in tree shown at the top of facing page.

Color swatches painted onto dampened paper, as in tree shown at the bottom of facing page.

This three-step sketch was produced by applying direct washes onto dry paper. The look is a little rugged because the edges are somewhat abrupt. I use this technique a lot to capture foliage. The texture of the cold-pressed paper helps to create the suggestion of individual leaves on the tree. It also helps to soften the overall effect of the image. With this approach, I can capture the personality of different types of deciduous trees.

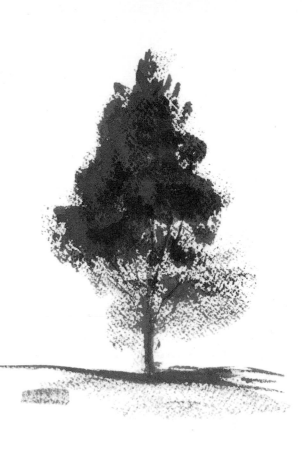

As you compare these two examples, the differences ought to be obvious. In this sketch, each layer was applied to a dampened section of the paper. Consequently, there are areas of very soft color blending into lighter and darker planes. The overall softened effect is more atmospheric.

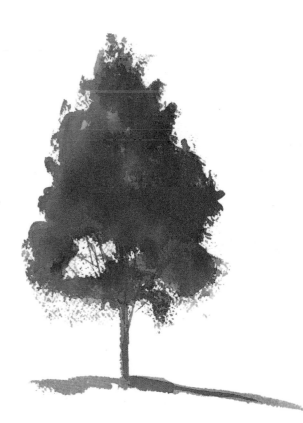

28

Q: At times during the development of my painting, I feel as though I am losing my direction. Can you offer any suggestions?

A: You should simplify the subject matter and the lights and darks of your painting in the initial stage. Carefully think out and plan the colors and washes of your main areas. With a strong basic framework, you will run into fewer problems later.

In order to stay on track, there are a few factors that you should take into consideration for the initial stage of your painting. For instance, you should simplify your subject matter and then plan out your lights and darks (use preliminary sketches if necessary). With a simplified approach, you will have more control over your painting and less confusion in later stages.

It is not uncommon to have a feeling of misdirection from time to time when working in the glazing technique. Probably one of the most important things you can do is to relax and allow yourself to think the process through. No matter how much you plan ahead there will be times when a wash will be stronger or weaker than you had planned, or a wash will create an effect you hadn't expected. At this critical point, you can either panic and give up, or you can turn the situation to your advantage. Learn to be flexible. If your concept is so rigid in your mind that it will not allow for any variation, you are probably doomed to frustration from the start. This doesn't mean that you should go to the other extreme and have no preconceived standards and just accept anything that happens in the painting process. When you pick up the brush, you are in charge; no one else can really help you realize that inner image you are trying to create.

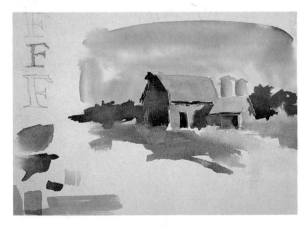

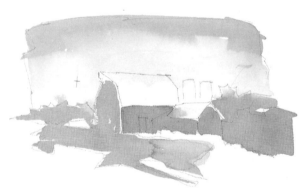

Let's look at the construction of this watercolor demonstration. The pieces fit together almost like three big jigsaw blocks: 1. The sky wraps around the barn and the silos. 2. The foreground blends into the barn as well as the trees. 3. The final shape is the pattern of darks that help to define the overall painting. These areas were planned and organized so that the sections would be in harmony with one another. For example, if you look just

beneath the surface of the foreground, the tree line, and the side of the barn, you will notice that all three areas received the same preliminary wash. In the initial stage (see the schematic sketch to the right), I had only two dominant shapes of color—the blue of the sky and the yellowish wash found in the barn, tree line, and foreground. The darker detail was dependent on this preliminary color framework.

In this first stage of *Misty Landscape,* you can see how I simplified my approach. Here you see three basic elements: the sky, the green foreground, and the house which has been left white. Notice how I arranged the colors to call attention to the play of afternoon light upon the house. With this type of framework, it will be more difficult for me to lose my way because each application of paint helps to bring me closer to my objective. The sky is a mix of pale vermilion and Thalo blue. The first foreground wash is Thalo yellow-green with a small amount of Thalo blue. I allowed the Thalo yellow-green to get rather intense toward the central foreground.

This preliminary step clearly shows the composition and framework for the later stage.

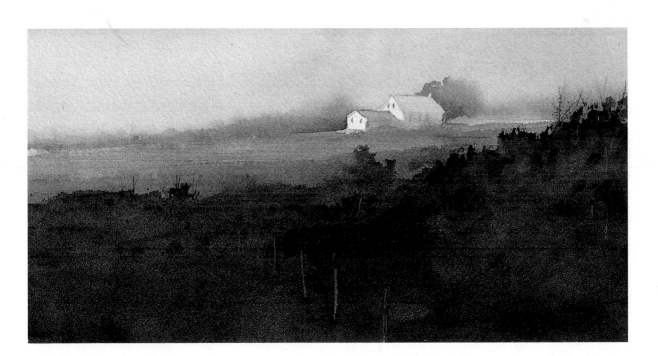

Misty Landscape. Watercolor on 140 lb. D'Arches coldpressed paper, 5½ x 11" (14 x 28 cm). Collection of the artist.

For this second and final stage, it was time for me to develop the finishing touches. If you compare stage one to this stage, you can see how the glazing technique really helps to create richer color in the shadows of the foreground. It also helps to spark contrast in the middle ground.

Once the preliminary washes were done, I was able to develop my lighting and contrasts without any major problems. Notice that for the tree line I used a wet-on-wet technique using Thalo blue and some vermilion to create the misty feeling around the house. In the foreground, I simply changed the ratio of Thalo blue to vermilion to help create the darkest values in the painting. The overall dark green is a mixture of Thalo yellow-green and Thalo blue.

Q: What if I don't like the effect I am getting; can I make changes in the painting?

A: Yes. You can rework areas by adding or eliminating certain elements or colors. It all depends on the type of changes you want to make.

It all depends on what type of changes you are trying to make. As with other watercolor techniques, you can try cropping, adding new elements, or sponging out old ones. For example, at various stages you can alter the effect of an underpainting even though it is usually made with a staining color. Since stains resist sponging out, you may find it easier to increase the strength of your washes to overpower the effect of the underpainting. If, however, the underpainting is very strong, you may be locked into your original course of action. The best bet is to plan your painting carefully.

In some situations, you may be able to alter the mood by adjusting one color over another. For instance, you can add layers of shadow wash and then scrub or scrape out highlights. Certainly, you can rework areas, and if all else fails, there are opaque paints as a last resort. If none of these solutions work, you may want to start over.

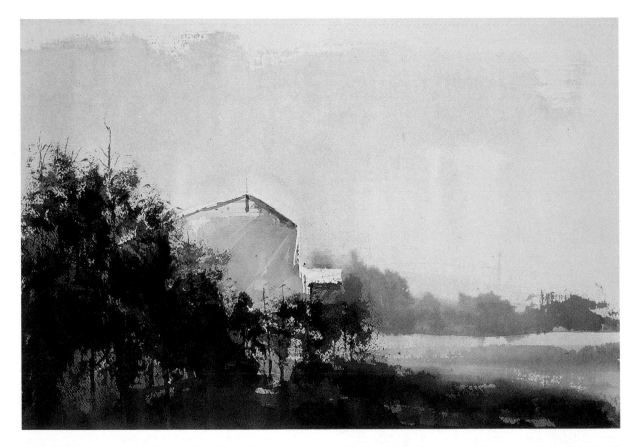

Here is the first stage of a small watercolor, 14 x 20″ (36 x 51 cm), that was done as a demonstration. I was working in a limited time frame (forty-five minutes), and I wasn't happy with the final result. The washes were working well but somehow the composition was not all it could be. Everything just wasn't working together. I liked the lighting on the barn and some of the effects in the trees in the foreground but everything else was lacking somehow.

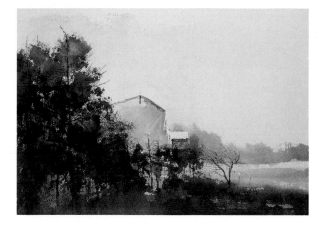

I decided that the trees needed to have more dominance in the foreground so I increased their height. Then I added the small fruit tree to the immediate right of the barn. I also applied an additional wash in the left section of the foreground of the trees. I let all of this dry thoroughly, and then I examined the effect. The changes had helped a little, but I was still not totally satisfied.

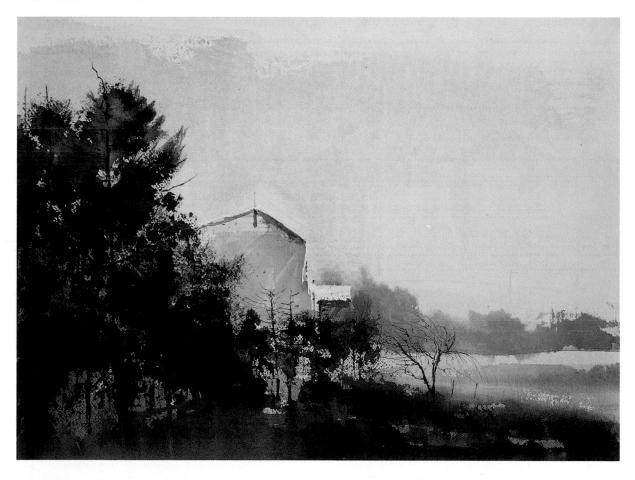

Several days later, I reexamined the work and decided that a little more refinement was necessary. You may have to look closely to see some of these modifications, but I do think they add to the painting. First, I strengthened the washes in the tops of the trees. In order to enhance the flow between elements, I added foliage to the tallest pine tree—the one nearest the barn. By applying darker washes over the lighter sky wash

to increase the height of the trees, I was able to "boost" the value of the color in the trees. This additional wash also adds depth by allowing some of the sky to peek through the stand of trees. After this, I added small spots of darker color to some of the shadow areas in the barn, under the eaves, to help balance the harmony in the overall piece. These are perhaps small adjustments but they definitely enhance the work.

Taffy II was completed several years ago. Even though I signed it, I was not completely satisfied with the effect; the cropping and subject placement created a very static image. So I changed the piece.

Some of the changes were quite severe and perhaps daring, but for the most part, I think they helped. My first step was to increase the size of the image area, which I did by removing the mat. That enlarged the dimensions to 25 x 35″ (64 x 89 cm). Then I began to contemplate how to apply additional darks to the background without it being obvious. How could I make the best use of the wash that was already there? I started on the left side of the door jamb, where a small vertical strip of dark wash helped define the boundary. After dampening the area from the edge of the jamb to the edge of the paper with clear water, I began to flood a dark wash of Thalo blue and Winsor red into the space. This worked partly because it was a shadow area, so that I could more easily feather my new wash into the existing color.

Once it was apparent that this approach was going to work, the next step was to intensify the shadow on the left, leading up to the edge of the

basket, just under the door. This was accomplished with three layers of diluted Thalo blue and Winsor red wash. (One heavy wash could have ruined the painting! I had to apply light washes very carefully, experimenting until I found the proper harmony.) Each layer was allowed to dry before the next was applied. To prevent any unwanted harsh wash lines, I dampened more of the paper than the area to be worked, so that each new wash ended at a definite edge (such as the edge of the basket).

After the larger masses were adjusted, I added some detail work to blend the new with the old. In the far left area of the floor, I added a floor joint. Next I dry brushed some darker shades into the vertical jamb to blend the light and dark areas together. Then I moved over to the right side. My first step there was to strengthen the thin shadow on the right side of the door jamb. Then I began to strengthen the shadow form by scrubbing out more of the dark to call attention to the baseboard. While I was doing this, I got the idea of adding the Mason jar, which I created by scrubbing out that area and then carefully adding passages of darker wash to define shadows and some detailing.

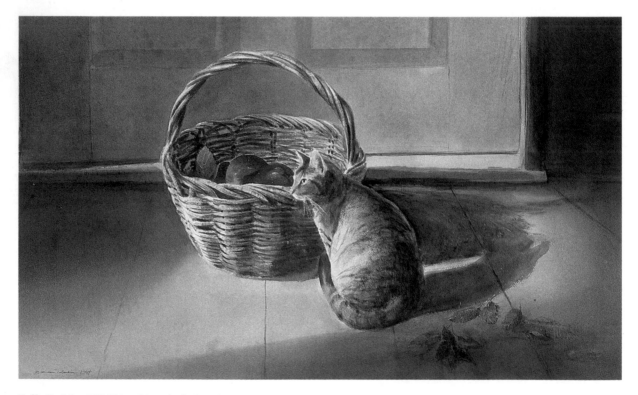

Taffy II. 20 x 32″ (51 x 81 cm), first state.

I knew this painting needed something, but I couldn't be sure of the exact solution. After mulling it over for a while, I finally quit analyzing and decided to make some changes.

This diagram shows my method of dampening the watercolor to avoid any unwanted harsh, abrupt edges in my work. The blue dotted line shows the boundary I created with clear water. Notice how it follows the preexisting lines of the painting.

I did this sketch to help improve the composition. I shifted the basket to the left to get away from the riveting effect of the two parallel vertical lines of the door. Since it was physically impossible for me to alter the door, I subdued it by increasing the shadow values and minimizing the contrast value in the details.

The dotted line around this first wash shows the amount of paper I dampened to give the wash room to feather out naturally. Soft, indistinct edges are far easier to blend than abrupt ones.

In this wash, not enough of the paper was dampened. Consequently, the wash grew out to the edge of the damp boundary and created a harsh edge on the left side.

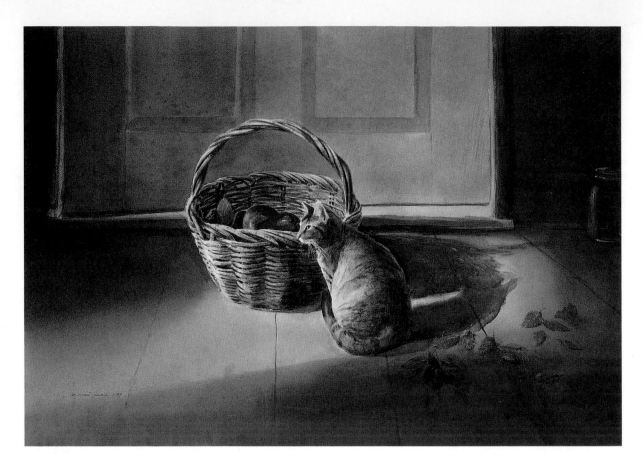

Taffy II. Watercolor on 260 lb. D'Arches cold-pressed "double elephant" paper, 25 x 35" (64 x 89 cm), second state. Collection of the artist.

After all of the changes had been completed, there was still something lacking. I began to rework the leaves in the foreground by creating additional leaves. The placement of these leaves seemed to help the movement of the shadow areas. After examining the work closely for several days, I strengthened some of the fine joint detail shadows in the door and the scratch marks on the lower portion of the door. Then I intensified some of the shadow detail in the basket around the cat's nose.

30

Q: Sometimes when I am glazing, my subject matter looks flat and uninteresting. What am I doing wrong?

You are failing to build a proper contrast between the elements within your painting. There are a few reasons why this may be happening. For example, it could be that you are applying washes that are too strong in the beginning stages. Your initial washes should be very pale or weak looking. Keep in mind that watercolors have a specific spectral range, which means that you can only get watercolors to perform in a certain range of color strength. For example, in the darkest washes, the color will only go so dark. If you want a very powerful black, you are going to have to use a mixed media or add India ink. By the same token, to get a very dense light, you will have to add some opaque white. Either choice destroys the effect of true transparent watercolor. Obviously, if you are a purist this is something you would like to avoid. Remember that the darks and lights found in a good, snappy watercolor are the illusion created within the specific range of the colors used. If you compare a crisp, contrasty watercolor to an oil or an acrylic, the watercolor may appear to be weaker in color strength. However, when judged on its own merits, watercolor is sufficient in color strength. You can create powerful contrasts by carefully manipulating the lights and darks.

Another possibility is that you may be creating a problem by failing to think and plan out your lights and darks correctly. If you apply an even wash across a sheet of paper, covering the entire surface without thought to the areas that should receive a light wash or no wash at all, you will most likely produce a flat painting.

Finally, remember to acquaint yourself with the characteristics of transparent dye colors as opposed to the earth pigments that tend to float on the paper. The proper use of these colors can play a big role in the success of your watercolor.

A: You are probably applying washes that are too strong in the initial stages, or you are not planning out your darks and lights properly.

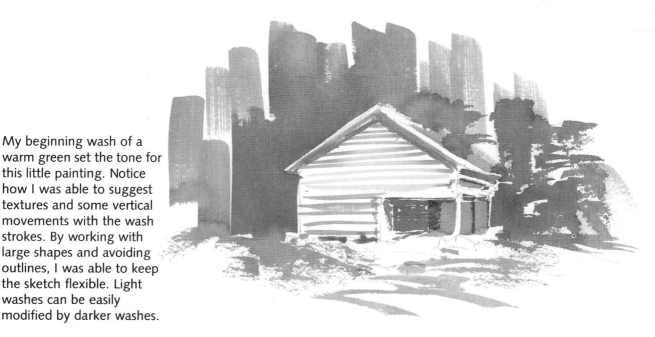

My beginning wash of a warm green set the tone for this little painting. Notice how I was able to suggest textures and some vertical movements with the wash strokes. By working with large shapes and avoiding outlines, I was able to keep the sketch flexible. Light washes can be easily modified by darker washes.

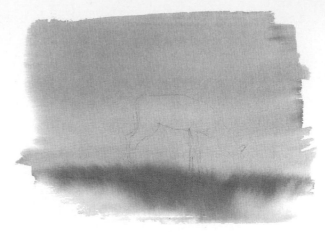

This sample of an initial wash has very little contrast between the elements. Note that the deer is completely covered with wash, and the ground where the deer is standing is barely perceptible. This combination can produce a very powerful yet subtle-toned watercolor, but for the beginner, it can also produce frustration because of the lack of contrasts.

Here is the same subject with similar treatment, except that the background wash is lighter and more varied. Variation equals visual interest, and varying your washes from the beginning will ensure a more pleasing work. Here I used a wet-on-wet technique to bleed the ground into the background wash, and lightened the wash near the horizon to suggest changing light or perhaps a thin mist. This is the beginning of a much more promising piece.

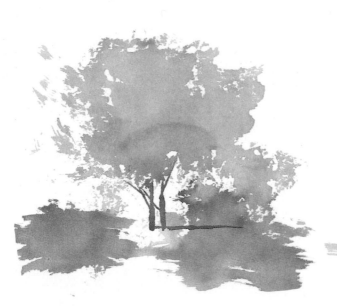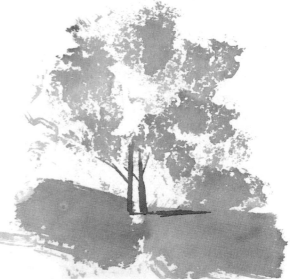

In this sample, I used lighter washes to create the shape of the tree. The only element of real contrast is in the trunk and the shadow. The grass is about the same value as the tree. Notice that these washes are much lighter than the ones used in the first samples. This will give me the opportunity to add contrasting colors as I develop the scene.

This time, using the same washes as in the previous sample, I added more contrast. For instance, in the center of the leaf mass of the tree, the white of the paper shines through in the shape of a bough. There are also additional areas of white in the tree and around the edges. The result is a light and airy visual effect.

Compare these photos and sketches to see how I exaggerated contrasts to create liveliness.

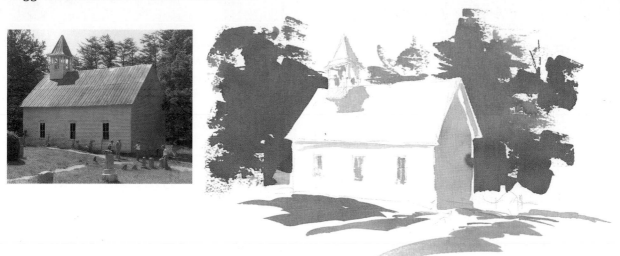

In this sample, all of the washes are dilute. But even in a dilute state, note that the greens are warm on the right side and cool on the left. There is also a cool tone in the foreground. Now look at the cool shadow on the church. If you squint your eyes, the shadow is almost the same gray value as the background trees. By leaving large areas unpainted in the initial stages, I can make these areas exposed to the white paper darker or cooler as the painting progresses. In fact, I can leave the church area white until the final stage. This gives me ample opportunity to develop all of the surrounding areas before adding detail to the center of interest. With this approach, I can avoid adding too much detail too soon, which can lead to overworking a painting.

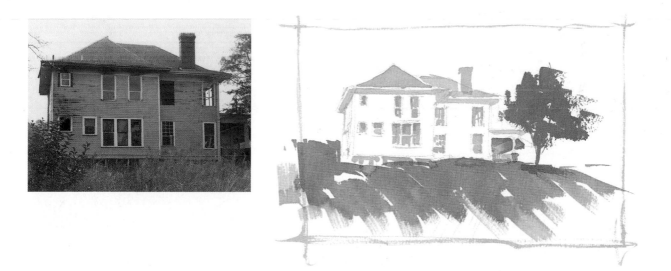

This old abandoned house had a lot of nice qualities, and I liked the idea of making it more prominent by playing up the angle on the hill. As you compare the sketch to the photo, you will see some major changes. For instance, the dark house in the photo has become white—but that could change as the painting develops. By reserving the white in the house, I have more options for developing the surrounding passages and playing with the contrast of the house against the background. The contrast may be in the hue or value, or in the amount of detailing. My main concern at this stage is to develop a strong contrast base so that the painting will be crisp and snappy.

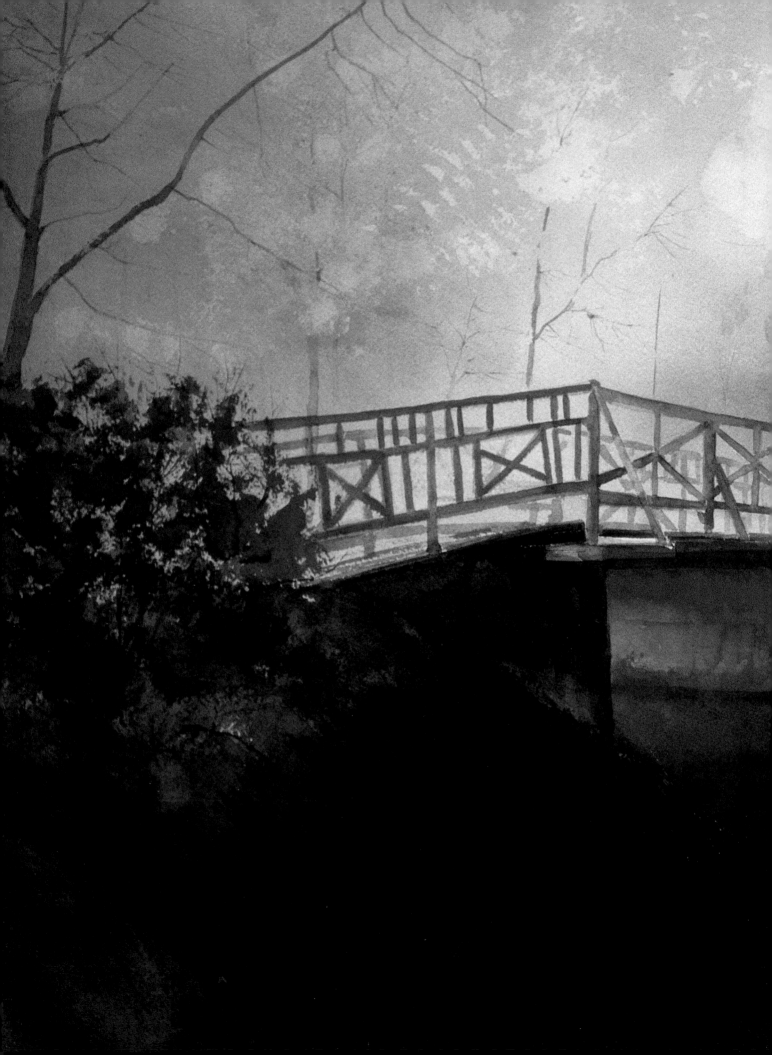

Creating Specific Effects

Q: At times I like to use India ink and opaque color in my paintings. Can I still use them with the glazing technique?

A: You should use India ink and opaque colors only during the final stages of the glazing process.

Yes, provided you do not attempt to use these colors in the beginning stages of your work. Remember to follow the rule about using opaques as finishing touches for most paintings; otherwise, opaque paints tend to make any overlying color appear cloudy or murky. By reserving the more opaque colors for the final stages, you ensure that all of your color passages will be clean and crisp.

For best results and most effective coverage, remember that gouache should be mixed with water to the consistency of heavy cream. India ink can be used full strength or diluted with water.

These colors should be used only to enhance the watercolor pigments, not to replace them.

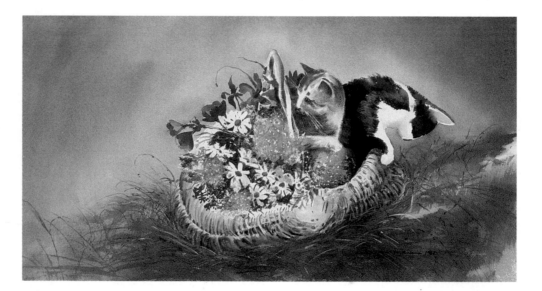

Two Cats in a Basket. Watercolor and acrylic on 140 lb. D'Arches paper, 22 x 31½″ (56 x 80 cm). Private collection.

Once the piece was completed, I wanted to add a softening effect so I used an opaque color in the lilacs. I mixed Winsor violet with white acrylic and applied it with a dry natural sponge. After the flowers were completed, I brushed a few strokes of the mixture around the front of the basket to help produce color harmony.

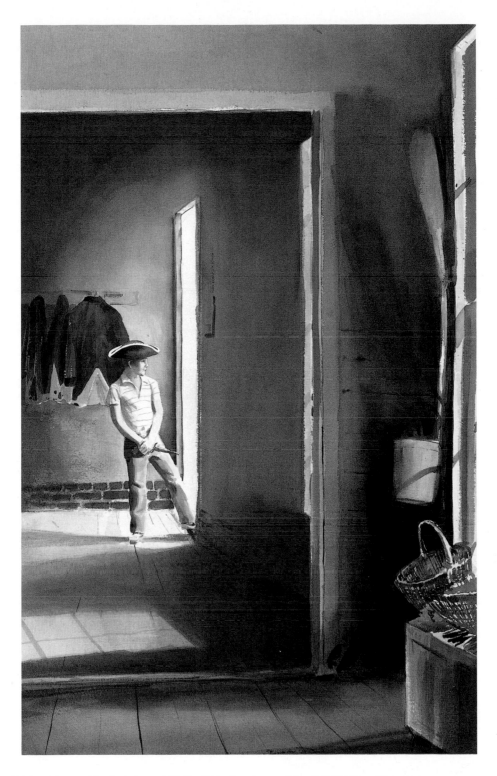

Day Dreaming. Watercolor and India ink on 140 lb. D'Arches paper, 35 x 24¾″ (89 x 63 cm). Collection of Geneal Rankin.

The India ink is evident in the foreground of this work. There is also India ink with vermilion in my son's tricornered hat and the cuffs of the coats on the wall. (I mixed the ink with vermilion here to soften its impact slightly; for most purposes it is too strong alone.)

The ink was just the thing the shadow area needed to snap everything together. I began this painting as a transparent work, and it would have stayed that way had I not decided to add that extra snap of black ink. The India ink helped to create more depth and form in the shadows.

Q: Sometimes I like to use a masking agent in my paintings. Can I do that and still use the glazing technique?

A: Yes, masking agents will offer you more options in glazing.

You can use maskoid, frisket, or similar masking agents with the glazing technique. The use of such materials is purely a matter of personal choice. By using this product, you will find more options available. The reason is simple. When you are glazing, you are putting several layers of color on the paper. Therefore, you have more than one opportunity to use masking. In fact, the possibilities are almost unlimited. You could mask out areas to obtain a pure white from the very beginning, or you could wait until later stages and mask out or reserve some of the other color passages. Instead of being limited by glazing, you will find your options are multiplied. Personally, I prefer to avoid the use of masking products, because I think it tends to make some elements of a watercolor painting appear stiff and unnatural.

For the following three samples, I used Grumbacher Miskit, which can be used on heavily sized watercolor paper as well as photographs. It is very easy to apply and remove. The Miskit is loaded onto a soapy brush. The soap is used to keep the Miskit from drying to a solid glob on the brush. Once the brushing is completed, the brush is washed out and the soap carries the Miskit off the brush. Regardless of the brand you use, be sure to read and follow the directions carefully. Failure to do so can cause you to ruin a good brush.

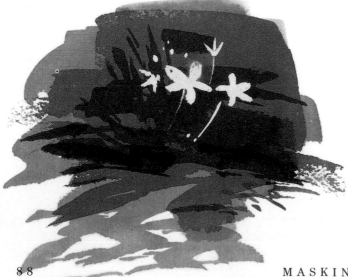

In this first sample, I applied the Miskit as the flower shapes to reserve the pure white of the paper. This is the usual procedure for masking out detailed areas of a watercolor. After applying four layers of wash, I carefully removed the Miskit, using the pointed edge of a kneaded rubber eraser. Notice how the white of the paper stands out in stark contrast, ready for the final touches of wash that will complete the painting.

For this sample, I wanted to create yellow flowers. For this reason, I applied the first wash of new gamboge before using any Miskit. After the new gamboge had dried, I drew in the flower shapes with the Miskit loaded on a soapy brush. After the Miskit was dry, I applied the remaining washes. When all the washes were dry, I removed the Miskit, leaving the yellow flowers. At this stage, the flowers can be refined with darker washes, and the painting would then be complete.

You can also use masking film on more than one layer of your painting. In this example, I applied Miskit to various areas of the white paper. After it was dry, I applied the first layer of pale green wash. Once the wash was dry, I put more Miskit on other areas of the paper, being careful not to disturb the Miskit that had been applied earlier.

Now I had two colors reserved, the white of the paper and the pale green of the second wash. After the second layer of Miskit was dry, I continued to apply washes over the entire sheet, working in all of the darks. After the washes were dry, I carefully removed the Miskit, leaving white and pale green blades of grass.

Q: Can I use the glazing technique along with a more direct technique in the same watercolor?

A: Yes. Glazing and direct techniques can be used together to create strong paintings.

Direct technique simply means to apply washes directly to the paper without building up layers of color. Hesitancy about combining direct and glazing techniques reflects a common misunderstanding about painting technique. In fact, combining approaches is a very good way to work, especially when you want to create special atmospheric and lighting effects. Use glazing to create a luminous sky, and direct washes for a dark, simple foreground. Or glaze a foggy landscape, and paint simple direct shapes of silhouetted buildings or trees. By using the two approaches in the same work, you can increase the law of contrasts and make a very striking pictorial statement.

Earlier I mentioned that in drawing you begin with nebulous lines and continue to refine and develop the image using stronger lines as the work develops. A painting should evolve along the same pattern, with pale washes used first and dark, direct brushstrokes used last. This method helps us maintain control and harmony.

I am going to use two examples to demonstrate my meaning. Study these examples and then try it yourself. Finally see if you can create some of your own special effects.

new gamboge
Winsor red
<u>Thalo blue</u>

blue dominance

new gamboge
<u>Winsor red</u>
Thalo blue

red dominance

<u>new gamboge</u>
Winsor red
Thalo blue

yellow dominance

These three neutral colors used in *Salt Marsh* have a strong unity. That is because they are all made from the same elements: new gamboge, Winsor red, and Thalo blue. The only difference is that the first patch on the left contains more Thalo blue; the second contains more Winsor red; and the third contains more new gamboge. The third patch was the color used in the first wash of the painting.

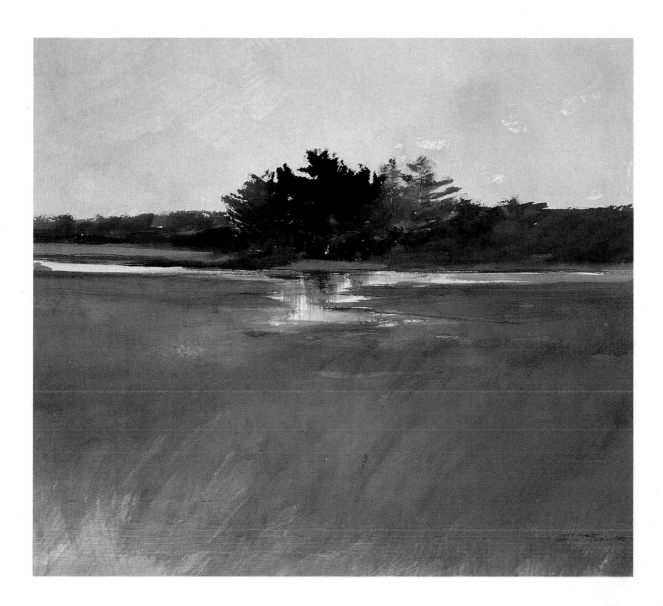

Salt Marsh. Watercolor on 140 lb. D'Arches paper, 22 x 30" (56 x 76 cm). Collection of the artist.

This watercolor began with a basic wash of Winsor red with new gamboge and a whole lot of water over the entire sheet. Look in the left-hand corner of the sheet, then at the sky and the water. All three areas are unified by this basic wash. After this wash had dried, I began to develop the painting. With a large square-edged brush, I applied a mixture of new gamboge and vermilion. Later I came back and used a pale wash of Thalo blue to create the effect of the grass. This was done by brushing directly on the dry paper.

In the early stage of development, I painted in the tree line. The first basic wash was composed of Thalo yellow-green and vermilion. The second wash was a mixture of indigo and vermilion. I flooded the second wash in a very powerful manner, creating variations in the intensity of the wash. This variation helps to convey texture and strength to the painting. The strong light wash underneath served as a color boost for this otherwise drab combination.

In the final stages, stronger washes of new gamboge and vermilion were applied directly along the bank of the water. On the right side of the scene, near the water, a wash of new gamboge, Thalo blue, and a little vermilion added some green to this side of the painting. Some of the darker tree wash was dry brushed across the water to create depth and to unite the upper and lower painting elements.

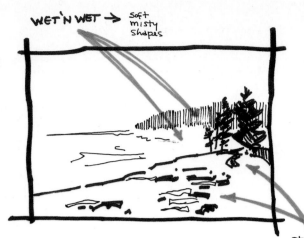

WET 'N WET → Soft misty shapes

DIRECT WASH → Strong dominant shape.

Acadia is one of my favorite spots along the coast of Maine. I especially like it in the early spring when the weather is misty and wet, which I wanted to convey in a small watercolor.

Before beginning the painting itself, I did this diagram to establish where I would apply the wet-on-wet technique and the direct washes. By setting up a contrast such as hard areas against soft ones, I can create a tension that is similar to pitting warm colors against cool ones.

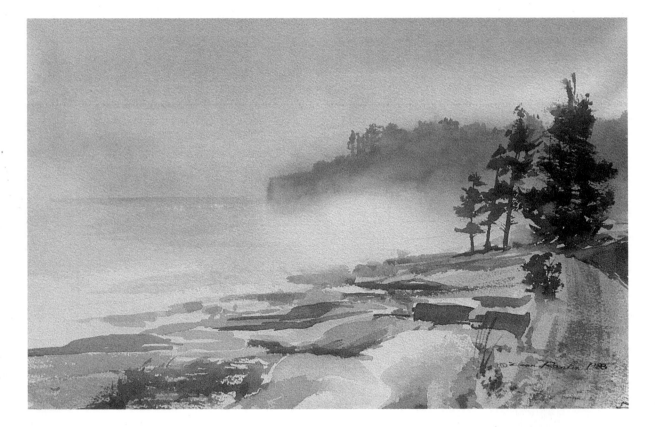

Acadia. Watercolor on 140 lb. D'Arches paper, 17 x 21½" (43 x 55 cm). Private collection.

My first two washes established the sky and the swirling patterns of mist. Then I produced dark patches in the treetops on the distant cliff by placing the tip of a brush loaded with wash into these almost dry areas—that is, I used a basic wet-on-wet technique over a previously colored surface. Once all had dried, I needed to establish a horizon line on the ocean. I wanted a distinct edge

but not an abrupt one, so I used a dilute wash on dry paper.

For the foreground, I used direct brushwork with light washes. The three trees grouped together are a mixture of Thalo blue, indigo, and Winsor red. The tree in the forefront is made of the same washes; however, its basic shape was dampened, and indigo with a touch of Winsor red was applied into the damp mass and allowed to bleed. One of my last touches was to dry-brush the sweep of the road bed on the right side.

34

Q: Can I combine wet-on-wet techniques with the glazing technique?

A: You have more control of the wet-on-wet technique when you use it with glazing.

There is no question that these two techniques can be incorporated to create some very striking effects in any subject. One of the advantages of glazing is that you can harness and make the most out of the explosive potential inherent in the wet-on-wet approach. For instance, it is customary when working in wet-on-wet to overcompensate for the strength of a wash in order to allow for the inevitable fade-out that will come as the piece dries. If you are applying layers of wet-on-wet on top of one another, you don't have to worry too much about the loss of color as a wash dries. As you apply layer over layer, each passage of color is going to amplify the previous one. In addition, it can also be said that the wet-on-wet technique is at best unpredictable and very nearly impossible to control. However, with glazing you can exert a great deal of control over a wet-on-wet passage. For example, you can confine the area in which the technique is used, to the sky, the distant tree line, the foreground, or any other part where you want the special wet-on-wet effect.

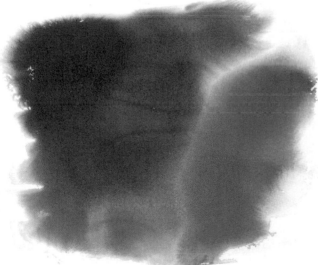

Example of wet-on-wet technique. Glazing can help you control the wet-on-wet technique.

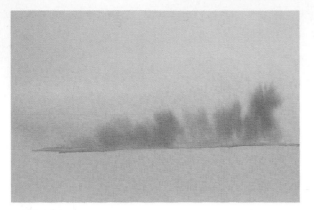

A tree line can be built using wet-on-wet, glazing, and direct techniques. I applied the first layer of wash composed of new gamboge, Thalo blue, and vermilion to a dampened surface and let it bleed.

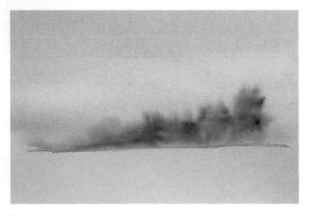

After the first wash was dry, I dampened the paper again with clear water and a second wash was applied. This time I increased the amount of Thalo blue to produce a blue dominance. The wash was also allowed to bleed. Now there are two layers of wet-on-wet wash, one juxtaposed over the other; notice how they give a soft, dreamy look to the tree line. The first wash was a neutral yet warm color, while the second wash was a stronger yet cooler color. Each color dominates a certain portion of the tree line, but they also blend to create a third shade while providing a convincing foggy effect.

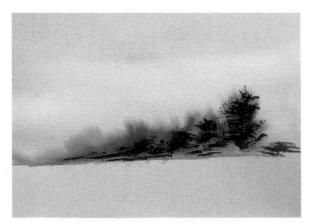

This final step is for those who wish to go a little further with the treatment. I applied this final wash directly to dry paper. The tree forms were created using the edge of a square-edged brush. The sheer strength of the forms, plus the power of the color, forces the softer-edged shapes into the background.

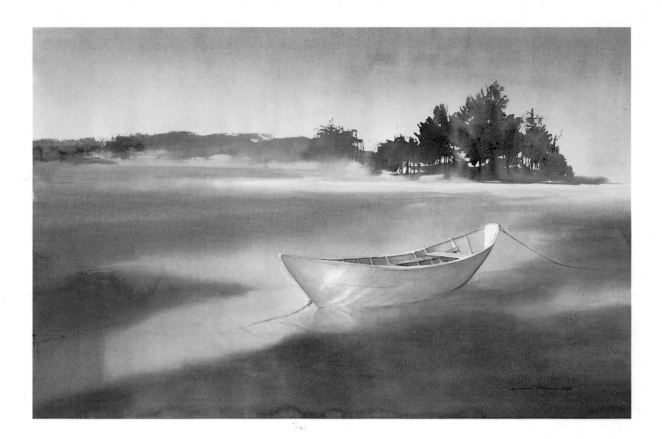

Low Tide. Watercolor on 260 lb. D'Arches paper, 26 x 42" (66 x 107 cm). Private collection.

This watercolor gives the appearance of being a very wet watercolor. While it has many wet-on-wet passages, they were built up over one another in several stages.

In the first stage, the entire sheet was dampened—only the boat was kept dry and free of any wash. The rest of the sheet received a wash of Thalo blue, manganese blue, and a little bit of vermilion. This wash was then allowed to dry thoroughly—it set the tone for the whole painting. After the paper was dry, I dampened it with clear water. Then a layer of Thalo blue and vermilion was applied to the sheet. This wash was allowed to bleed down to the horizon, keeping most of its strength toward the top.

After the first stage was dry, I dampened everything except the boat from the horizon line down to the bottom of the sheet. Into this area, I applied a very dilute wash of new gamboge, which was allowed to seep and gain strength toward the darker portion of the bottom of the sheet. The absence of yellow toward the horizon helped to make this area cooler and therefore recede in the picture plane. Since the middle ground toward the horizon began to dry more quickly than the bottom of the sheet, I used a large brush and

began to paint in the tree line with a stronger mixture of Thalo blue and vermilion. The sky was already dry, and the horizon area was drying unevenly. You can see that I took advantage of this to create trees that were sharp and definite at the top and feathered toward the bottom. While this wash was drying, I added touches of Thalo blue and indigo to some of the darkest trees.

Next, I turned my attention to the foreground elements, leaving the boat for last. I layered the beach with several passages of Thalo blue and vermilion. The under wash of new gamboge helped to impart a slight greenish cast to the tone. In between passages of wash, I splattered darker color over the foreground. The object was to create a subtle texture like wet sand. What you see is several layers of splatter, some on damp paper but most on dry.

Finally it was time to finish the boat. The shading for the boat was composed of Thalo blue and vermilion. The washes on the interior of the boat were applied to dry paper in a very direct technique. Several of the sections received more than one wash to increase their strength. The white of the paper was used for highlights on the interior of the stern and on the outside of the bow.

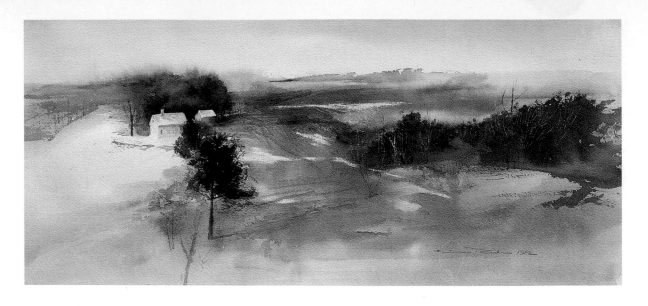

March. Watercolor on 140 lb. D'Arches paper, 18¾ x 32½" (48 x 83 cm). Private collection.

Here is another example of making use of controlled wet-on-wet bleeds. Look at the sky and compare it to the foreground in the snowy areas. You should be able to recognize a similarity in the color range, because a basic wash of Thalo blue, new gamboge, and vermilion was flooded over the entire sheet, except in the area that contains the house or in some of the smaller snow patches. Once this wash was allowed to dry, I dampened the surface and began bleeding more color into the landscape. The colors used for the beginning washes were Winsor red and new gamboge. Since initial washes were rather pale, their edges were not abrupt so that layers of color mingled together, creating a soft but multicolored patchwork.

Once I was satisfied with the landforms created by these first few pale washes, it was time to begin defining areas. I used a very transparent wash of Thalo blue and Winsor red to create the cooler blue-gray passages seen in various parts of the picture, including the most distant stand of trees on the horizon. While this color looks filmy and atmospheric, I painted it in on dry paper.

The stands of trees in the middle ground and behind the house are the same colors used for the other trees, only the ratios have been changed, with more Winsor red and Thalo blue dominating the color mix. Behind the house, you can see where one area of Thalo blue was allowed to dominate, helping to give the illusion of wood smoke in the air. The black tree in the foreground was a mixture of Winsor red and Thalo blue in equal portions. This makes a very good optical black. You will see wisps of this same color in other areas of the foliage. It helps to heighten the contrast between lights and darks and define the form of the trees.

As you look at some of the tree lines, you can see the effect of the wet-on-wet technique, where light washes were built upon one another. The final darker passages were then painted over the lighter areas in specific dampened areas. You can look for clues since a sharp edge denotes dry paper and a misty edge denotes moisture. Final detailing was done with a small pointed sable brush and an X-Acto knife.

35

Q: Is it possible to incorporate dry brush with the glazing technique?

Yes. Dry brush works well with the glazing technique. You can begin your painting with a series of glazing washes, and then use the dry-brush approach for hatching, stippling, feathering, and daubing to finish. This is a very useful method when you want to create the illusion of meticulous detail. Throughout this book, you will find some paintings done this way.

Historically, the dry-brush technique was refined and utilized by many turn-of-the-century illustrators, most notably by newspaper and magazine illustrators who were often pressed by unyielding deadlines. The trick was to find a reliable method for creating convincing illustrations that would fit into the schedule and would be somewhat foolproof. Dry brush with ink wash became a preferred method. It relied upon a basic under wash and final refinement with a nearly dry brush to create and refine texture and form through a series of stipples, hatch strokes, daubs, and occasional glazes or overwashes. Considering the technique, it should be clear that dry brush with glazing washes is a natural combination.

You should keep in mind that pigments such as ultramarine blue, siennas, and umbers can create opaque, chalky, or heavy passages if used too early in the glazing technique. Sometimes in a dry-brush painting these colors can also contribute to a lusterless, overworked look. Therefore, in most cases, I suggest that you use transparent staining colors in the initial washes.

There are also a few things to be aware of if you want to paint in dry brush. The dry-brush technique is very versatile, and it relies upon washes as well as strokes and stipples. In working with a brush, there are several things to keep in mind. For instance, you can handle beginning washes like any other watercolor approach, making use of a fully loaded brush. But once you have applied several layers of color, you should reduce the amount of water used in the brush. At this stage, you should use a half-loaded brush. This degree of moisture is right for daubing and glazing.

Incidentally, you can use a tissue to blot a daub if it appears too strong. You can repeat the cycle of daubing, stippling, and hatching with blotting if you like, to create controlled textures. When you use the hatch stroke, you should reduce the amount of water in the brush even more; at this stage, the brush is merely damp. You may have to practice to get the feeling down. The object is to have enough moisture to produce a thin pencil-like line. In hatching, you will be using the point of the brush to draw very much like you would a pencil. But if you use small riggers or other thin brushes, bear in mind that you will need to increase the amount of water in order for them to perform well.

Remember, the dry brush is used for the finishing touches. These are the final, fine strokes, where the brush is used like a pencil to develop the finished look of the painting.

A: You can use the dry-brush approach in the final stages of your painting to produce hatch, stipple, feather, and daub strokes.

The basic strokes used in dry brush are feathering, hatching, stippling, and daubing. To begin painting, your brush should not be totally dry. Swirl it around in damp pigment on your palette. Then squeeze most of the moisture out at the base of the brush, using a tissue or some other absorbent material. The pigment on the tip of the brush should be left intact. To make sure that your brush is operating properly, drag it across a piece of scrap paper. The moisture level is correct when the paint leaves a rough mark.

To create a feather stroke, where the edges are feathered and easy to blend, you need to use a fairly large brush, allowing it to spring against the paper. In a stipple stroke only the tip of the brush touches the paper. If you press a little harder, you will have a daub stroke. Finally, the hatch stroke is actually a technique. You can hatch, crosshatch,

and double or triple crosshatch. These strokes are used to create graded tones and to add interesting texture to the image. Large masses of color should be created with washes.

The following step-by-step demonstration incorporates glazing and dry-brushing techniques to develop the image. As you will see, each step emphasizes a specific element: overlaying colors to suggest form, adding detail, and unifying all the colors and textures achieved earlier. (Unless otherwise stated, all washes were allowed to dry before another was applied.)

Hooded Mergansers. Watercolor on 140 lb. D'Arches paper, 12 x 16″ (31 x 41 cm). Collection of the artist.

For this painting, I wanted to create an effect of early morning with the first rays of light beginning to break through the mist on the water. There is a strong contrast between a soft wet-on-wet background and a fairly sharp dry-brush rendition in the point of interest.

My first step was to set the mood for the painting. In the first couple of washes, the only portion left dry was the white areas on the two ducks; everything else received a layer of pale new gamboge. The next layer consisted of dilute Thalo blue mixed with a very small amount of vermilion. Then I mixed a strong blue shade to create the illusion of ripples in the water.

In the middle ground, I dampened the sheet and carefully applied washes that bled out to create the soft illusion of haze on the horizon. Then it was time to work on the birds. While the detailing of the birds relied on a certain amount of dry-brushing in the later stages, I first needed to apply the main colors. Starting with the female, I dampened the body and washed in a mixture of

new gamboge with vermilion. While this was drying, I added a stronger mixture of new gamboge into the rusty patch on the male's side. After both areas were dry, I washed in a pale shade of Thalo blue on the head and back of the male. I used the same wash to create soft shadows on the back and neck of the female.

With the form developing accurately, I began strengthening some of the color in other areas of the birds. Beginning with the lighter values, I increased the strength of color in the rusty patch on the male and the duller browns on the female. The next step was to wash in the Winsor violet on the male duck. A small amount of this wash was brushed into the female's back just to harmonize the color relationship. When the area was dry, I washed in some small portions of Thalo yellow-green in the head and neck, to create a contrast with the violet and to produce an irridescent effect. Both ducks were finished by using dry-brush strokes and stipples. This process is like drawing; it can produce fine line details.

Here is the feather stroke painted over an under wash of Thalo blue. To produce a feather stroke, you need to use a red sable brush that is at least a size 6 or larger in order to get the right feel or spring. This stroke can be used for developing graded tones, blending, or softening edges of color. You can also use it to tone down or intensify a color in a given area.

In this sample, you see two colors glazed over a portion of the feather strokes and the under wash. The feather strokes help to build texture and form as well as modify color; while the glazes help to modify the texture and visually unify the section being worked.

The stipple (top) and daub (bottom) strokes are both made with the tip of the brush. The only difference is the amount of pressure exerted. This sample shows how these strokes look over an under wash. By using these strokes, you can produce various textural forms. For instance, it is possible to stipple many colors in close proximity to one another to create another color altogether. You can also overlap these strokes to create a wide range of color blends.

Here the stipple and daub strokes are shown with a layer of glazing over them and the under wash. Notice how the glazing modifies the effect of the strokes and provides unity to the stippled areas.

This is a sample of the hatch stroke. It is probably the most exacting, noticeable, and controlled of the strokes shown—used to build textures, define form, and create depth in the tone of a color.

Here you see hatching and crosshatching with glazes over portions of the strokes and the under wash. Once again notice how the glaze is used to unify color and texture into a pleasing whole.

Now let's take a look at how I applied some of these techniques to the male duck's head, which is enlarged here so that you can easily compare each stage with the finished image. Remember, unless otherwise stated, each wash was allowed to dry before another was applied.

A dilute wash of Thalo blue is applied to the head. Note that the blue is not an even tone. Instead I used the color to suggest lighter and darker areas of the form.

Next, a wash of Winsor violet is applied to the majority of the head. Each application of color refines the form of the head.

A small portion of Thalo yellow-green is washed in two key areas of the head. Since this color tends to be opaque, it can be used to create a wispy effect and produce an illusion of a glowing green. In contrast with the violet, the Thalo yellow-green gives an iridescent effect to the feathers.

Notice how this layer of Thalo blue tends to pull the other colors together. This is a strong example of the effect of glazing. Thalo blue is dark enough to unify the colors, yet its transparency allows the colors to hold their own.

GLAZING AND DRY BRUSH TECHNIQUES

Here, various dry-brush strokes are incorporated into the head—hatching, daubing, stippling, and feathering. I used a color mixture of indigo and vermilion with occasional daubs of Winsor violet. It is important to note that the long strokes are imitating the way the feathers grow. There is an old Eastern adage that says, "In order to capture the essence of reality, paint it as it grows." Good advice. Compare this step with the finished head. Look for all of the stipples, hatches, and strokes.

With all of the textural strokes completed, it is time for more glazes. There is no rigid time set for a glaze, but it should be done after you have completed a portion of strokes. Remember, you use glazes to help unify areas of color or to darken a passage of tone. Use these glazes with caution. Your brush should not be loaded with a full charge of wash. These washes or glazes should be applied with a great deal of care and delicacy, and they should almost always be slightly darker than any preceding color. A wash as dark as or darker than the preceding one will create a transparent effect; a lighter wash over a darker one will look opaque.

GLAZING AND DRY BRUSH TECHNIQUES

Q: How can glazing help me create a foggy effect? How do the effects differ from those achievable with a wet-on-wet technique?

A: Pale glazes applied over one another can be used to create luminous foggy effects.

In order to create a believable foggy effect you must closely observe fog, and understand what it does to the subjects seen through it. What is really happening in a foggy landscape? Depending on many circumstances, the fog is either thick or thin. What effect, if any, does this have on the appearance of your subject? What is the color of the fog?

Perhaps these questions will seem almost ridiculous to some readers; if they do, be careful. It is quite possible that you are merely looking at the world around you without actually seeing. This admonition applies not only to fog, but to everything in your world.

Fog obscures our view. The thicker the fog, the more difficult it is to see anything else. This sounds obvious, but it definitely applies to the glazing approach to creating fog in a painting. When you depict fog with a regular wet-on-wet technique, it is only one layer of color. But when you glaze, you can overlap layers to create subtle illusions of fog, with richer and more luminous color. You can also have far more control over the fog's edges; you can make it trail off into wisps of varying thicknesses.

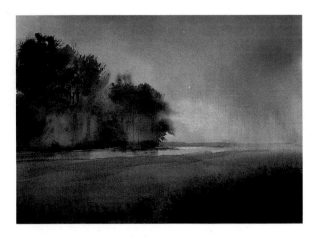

Daybreak, Okeefenokee Swamp. Watercolor on 140 lb. D'Arches paper, 11 x 14″ (28 x 36 cm). Collection of the artist.

This small watercolor was made on an early spring camping trip. In fact, it was one of the first times it got cold enough to snow in the swamp. An early morning haze covered the landscape as the sun came breaking through to burn away the fog and reveal the beauty of the swamp. I used a palette of new gamboge, vermilion, Thalo blue, and indigo.

The entire sheet was covered with a basic wash as seen in the sky. Once this base wash was dry, I painted the foreground in with a broad sweep of a large square-edged brush. The scrub brush in the immediate foreground was created using a natural sponge and several layers of various colors. The trees on the horizon in the mist are the result of several layers of wet-on-wet glazes, using Thalo blue with new gamboge and vermilion. Indigo was used for the darker passages.

The tree shapes were formed by using the flat side of a 1-inch aquarelle brush, and the trunks were made using the sharp edge. I allowed each layer to dry before applying another. In the latter stages, I would use the edge of the brush to introduce small spots of intense color in order to modify an area in the foliage.

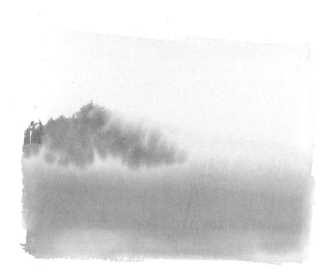

Here is a typical wet-on-wet rendition of a foggy shoreline using a palette of Thalo blue, vermilion, manganese blue, and new gamboge. First I dampened the entire sheet, and then applied a Thalo blue and vermilion wash evenly across the paper. I waited until the paper had lost most of the excess moisture yet was still damp enough to receive additional color. I brushed a mixture of new gamboge and manganese blue into the foreground. It immediately began to bleed upward and the color began to separate, creating an unexpected yet nice hazy effect. Once this color was in place, I immediately applied the Thalo blue and vermilion mixture for the trees.

The moisture level is critical for a foggy effect. In this instance the paper was damp. Had the paper been extremely wet, the color would have literally exploded across the paper and become very dilute on drying. Had the paper been nearly dry, applying a new wash could have damaged the preceding one.

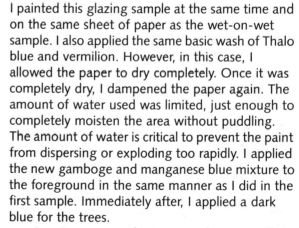

I painted this glazing sample at the same time and on the same sheet of paper as the wet-on-wet sample. I also applied the same basic wash of Thalo blue and vermilion. However, in this case, I allowed the paper to dry completely. Once it was completely dry, I dampened the paper again. The amount of water used was limited, just enough to completely moisten the area without puddling. The amount of water is critical to prevent the paint from dispersing or exploding too rapidly. I applied the new gamboge and manganese blue mixture to the foreground in the same manner as I did in the first sample. Immediately after, I applied a dark blue for the trees.

As you compare the two samples, you will note that the dispersal of the pigment on moist paper is not as great here as it is in the previous sample. However, you will also see that the hue retention is better with glazing. The reason for this is because the first layer of color was completely dry before the next color was applied. This creates distinct layers of color. With glazing, the result is a cleaner, more vibrant shade of color; whereas in the wet-on-wet approach, all the colors blend together on the same level on the sheet.

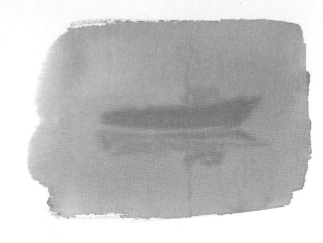

Here is another foggy effect using the wet-on-wet approach. Notice the fuzzy appearance of the boat. This was caused by the way the wash dispersed onto the damp sheet, which also had a damp wash on it. The effect is a little unpredictable because all of the elements go through some changes as they dry. I used a palette of new gamboge and vermilion for the background, and Thalo blue with vermilion for the boat.

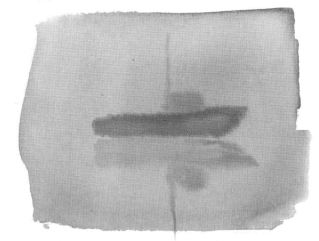

I applied the same washes in this sample as in the preceding one. The only difference was that the first layer of new gamboge and vermilion was allowed to dry completely, and then the sheet was dampened with clear water. Using a square-edged brush, I painted the image of the boat along with the reflection. Then I allowed everything to dry. In terms of fuzzy appearance, both samples are about the same. However, if you compare the color, you will see that the color here is more vibrant than in the preceding sample.

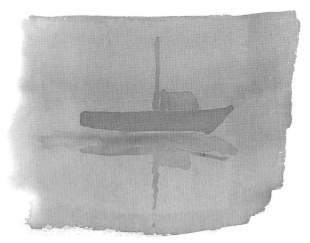

In this sample, you see a distinct advantage that glazing affords—the illusion of fog but with the image or shape in sharp focus. Once again, the same washes were used in this sample as in the preceding ones. The first layer of new gamboge and vermilion was applied and allowed to dry. Then I brushed in the boat image directly on dry paper. However, the wash was greatly diluted in order to create an obscured foggy image. I can also soften or blur edges by applying a dampened brush with clear water to any spot I wish.

CREATING FOGGY EFFECTS

37

Q: How do you create the striking effect of tree bark in your watercolors? It looks so natural.

A: Many kinds of bark textures can be created by glazing. The secret is careful control of color and texture.

The basic objective is to capture the essential shape of the tree with as few strokes as possible. This will help strengthen your understanding of the basic shapes that help depict a particular tree. This approach is not confined solely to trees; it is the essence of learning to depict anything.

When it comes to depicting bark you need to remember that every tree has its own characteristic bark pattern, shape, and color. Trees are like people; each has its similarities to other trees as well as its individual traits. Keep in mind that when observing trees from a distance, the method of painting will be different from a close-up view. Distance will simplify many of the minor details. You should always be more concerned with the overall appearance of your subject. For example, is the bark smooth or rough? Does it have a regular pattern? Is it checkered or knobby? Answering questions like these will help define your course of action in painting any tree.

The illustrations that follow give a closer look at the precise techniques I use for painting trees in the distance, in middle ground, and close up. One general tip: When painting trees wet-on-wet, use the outside edges of the tree as abrupt lines, but let the washes bleed inside the tree for indistinct edges there.

The first example is a rendition of a beech tree, which I painted at a distance. The overall shape of the tree was created with a brush loaded with clear water. Into this area, I introduced a mixture of new gamboge, vermilion, and Thalo blue. Using a 1-inch square aquarelle brush, I added color to the moist tree shape. The idea was to emphasize the most unique qualities of this particular tree, which stands about 150 feet from my studio window on the edge of a running stream. From this distance, I can tell that the tree has shaggy bark and most often a part of its trunk is exposed.

The other two trees in this group belong to the oak family. They have a different physical appearance from the first tree, and their bark is quite different. From a distance, they appear to be smooth. However, as I got closer, I found that they were indeed rough. Once again, I made use of the wet-on-wet technique for depicting these trees. I

dampened the basic shape with clear water, and used the edge of the brush to indicate the main features of the tree. I allowed the washes to bleed, creating soft, indistinct edges in some areas.

CREATING TREE BARK

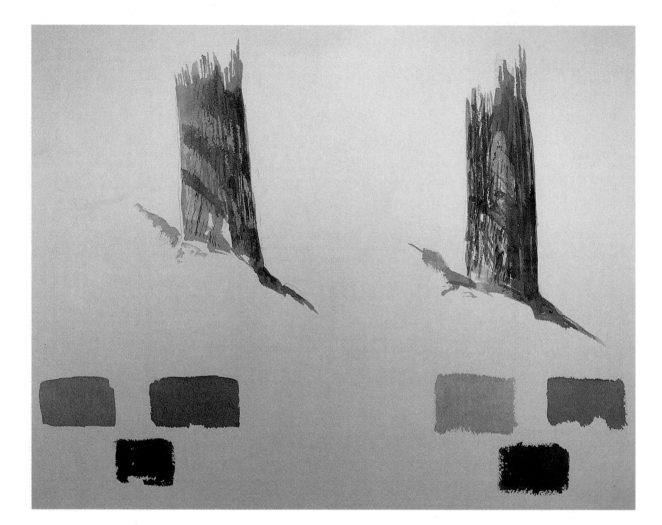

Using three basic values of gray, I have chosen to show two ways to develop the texture of a tree trunk in middle ground. In the first rendition, I washed the entire tree area with the lightest shade of gray. Once this dried, the second value was used to define the shadow areas. When this was dry, I used the darkest value to define the shadows in between the bark strips. The result is a very direct method of creating bark texture.

In the second attempt, the same washes were used but the procedure was modified a little. The first light wash was applied directly to the dry sheet. Once this area was dry, the left and right sides of the trunk were dampened with clear water. The middle of the trunk was left dry. Into this dampened area, I introduced the second gray wash. After this wash was dry, a second application was painted in a rough, irregular pattern. If you look carefully, you can see the evidence of the overlap in several places. While this second dark wash was still damp, I dry-brushed diagonal shadow strokes across the trunk, creating a little form and more texture. Working in the dry areas, I used direct wash as well as dry brush to create a convincing barklike texture on the tree trunk.

At close range, all of the elements of a tree come into play. When you are close up, you have to deal with elements that were nothing more than mere color in the more distant renditions. In a close-up view, things such as bark, twigs, moss, lichens, and so on must be dealt with in some detail. In order to be convincing, color, texture, and pattern must be closely controlled. For my model, I chose a piece of an oak limb from my firewood pile.

The first tentative washes set the stage for other washes. The first color washes are mixtures of new gamboge and Thalo blue; the stronger blue is manganese and cerulean blue. These washes are very pale; they have no definite edges toward the interior. The only definite edge is toward the outer boundary of the limb.

In this stage, I made mixtures from two distinct colors, new gamboge and vermilion. (In one mixture, I added some Thalo blue.) You can work new gamboge and vermilion in a fairly direct manner on dry paper. In fact, with these two colors, I was able to define areas in the limb. For example, you can see a warm color in the broken part of the limb, where a branch projects off to the lower front. The basic colors used up to this point were designed to define and unify the larger elements of the limb.

I cannot overemphasize the importance of these first two stages. Look at them carefully in relation to the next one.

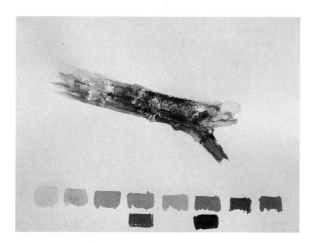

If you count the color blocks, you will see that I have added six more colors. The first new color block is directly under the fourth one. It is nothing

more than a stronger version of the color found above it. This fifth color block has more vermilion in it, and I used it to denote the cambium tissue between the bark and the wood of the limb. The next color is gray. It is a mixture of cerulean blue, vermilion, and a small trace of new gamboge, and I used it in the lichens. The two grays that follow, both the light and the dark, were used to define the shape of the lichens and the fissures in the limb. These grays were made from vermilion and Thalo blue. Color block nine is a green mixed from Thalo blue, vermilion, and new gamboge. It was used in the mossy part of the lichens, in the darker areas. The last color is a neutral gray, created from the same colors as the green, only the proportions of the mix differ. In this final stage, a great deal of dry-brushing and diluting of washes was done to bring everything into a proper relationship.

CREATING TREE BARK

38

Q: What advantages does glazing give in creating reflections and ripples in water?

Glazing enables you to build several layers of color, to create reflections and ripples in water without the danger of losing control. The overlapping of colors allows you to develop the subtle nuances of reflections. You can also produce ripples simply by applying a light under wash and then painting bands of darker color over it.

In order to paint water effectively, my first suggestion is to simplify. You can't capture it all, nor do you really want to. Your foremost concern should be to convey a realistic interpretation of water. Study water and its nature so you can produce a convincing rendition. In areas where you are painting waves, watch out for the whites. Spray and foam may look white but in reality very

little of it is actually pure white. Reserve your white for highlights in water just like you would on any other object you are painting.

The approach you take in painting water is going to depend on your distance from the subject, the lighting conditions, and the subject itself. For example, reflections in still water will be more distinct than those in moving water. Since water is such a reflective element it is affected by the things in it, under it, over it, and near it. If the bottom is murky and dark, chances are the water will be dark. The same water, with a clean sandy bottom, will be much lighter. The chemicals and silt that spill into the water also affect its clarity and color. Keep these things in mind as you paint.

A: You can build up layers of color gradually and simply to create these effects. This gives you more control of the medium.

Here is a simple two-step method for creating soft ripples in water. The first wash is a simple flat tone wash of Thalo blue and vermilion.

After the first wash had dried, I moistened the paper with clear water. The second layer consisted of manganese blue and a little new gamboge washed across the paper in three distinct bands. Since the paper was moist, the edges blurred to make a soft transition. The visual result is a soft pattern of slow ripples in water.

In this sample, I take the glazing concept a little farther. The first wash is a mixture of Thalo blue with vermilion. Using a 1-inch aquarelle brush, I imitated the action of the water.

After the sheet had dried, I dampened a portion of the paper with clear water. The second wash was composed of Hooker's green and Thalo blue. Once again, I used the brush to imitate a wave action. The brushstrokes on the damp side of the paper became soft and filmy. The direct washes on the dry side serve as a visual contrast and heighten the illusion.

Now it is time for the final darks. After the dry paper was dampened, I applied a stronger mixture of Hooker's green and Thalo blue. The first strokes were applied in selective areas of the foreground. After the paper was dry, I came back with the same color and placed direct strokes in the foreground and middle ground area. These strokes are easy to identify because they are dark with crisp edges.

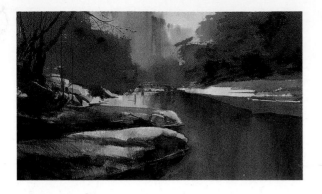

Mountain Mill. Watercolor on 140 lb. D'Arches paper, 19½ x 27½" (50 x 70 cm). Collection of the artist.

The setting is a deep, cool mountain stream running through the Smoky Mountains. Note the transition in color as the water moves out of shade into sunlight. The water has been treated very simply. There are no ripples or rapids. I started this painting with an underwash of new gamboge. Since I was going to make the water almost black, I wanted a powerful color underneath to keep the dark from becoming dull and dead. Then I washed several layers of Thalo blue with Winsor red over the immediate foreground. I applied vertical strokes in the water to create an illusion of vertical reflections from the trees. Since this water is moving, I did not define the trees in the reflection. However, in order to establish some feeling of reflection, I painted a portion of the bank in the reflection of the water. I darkened the rocks and the trees in the left foreground to produce a shadow effect that would enhance the light and dark contrast on the water.

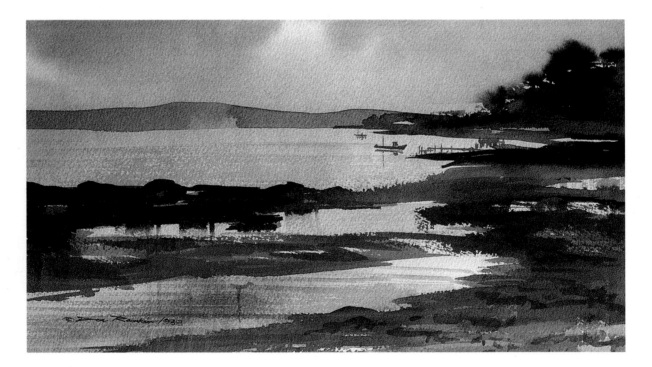

Twilight. Watercolor on 140 lb. cold-pressed watercolor block, 15½ x 21½" (39 x 55 cm). Collection of the artist.

This spot in Nova Scotia is part of Bras d'Or Lake, which means arms of gold. In the late afternoon, one can understand why it earned the name. In this painting, I wanted to capture the effect of the light as it bounced off the surface of the water. My first wash on this piece was a pale new gamboge. Some of this first wash can be seen in the sky and filtering down into the water. I used Thalo blue and vermilion for the sky. Lighter values of this same wash were dragged across the water to achieve a sparkling ripple effect. Remember that the water is a giant mirror reflecting the color of the sky; consequently the color will have some kinship. In order to heighten the effect of reflecting light on the water, I plunged the surrounding landscape into shadow by using basic dark shapes.

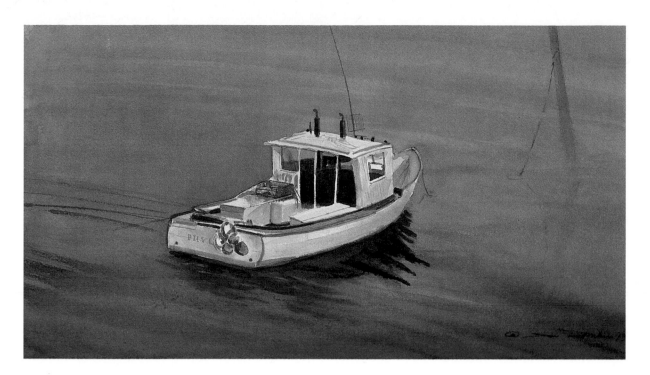

White Boat: Yarmouth. Watercolor on 140 lb. D'Arches paper, 12 x 18″ (31 x 46 cm).
Collection of the artist.

This small watercolor was my attempt to capture the deep blue rippling water. My palette consisted of vermilion, cadmium red deep, Winsor red, Thalo blue, manganese blue, indigo, and new gamboge. I created the water with several distinct washes. The lightest value in the water was the first wash; it was a mixture of Winsor red and Thalo blue. I used some of this same wash in two or three successive layers. The color was allowed to overlap, creating additional degrees of value.

Starting at the top of the painting you can see these distinct layers or bands of color. As the color comes toward the foreground, it begins to darken. At this transitional stage, I switched to a wet-on-wet method in order to blend the super dark values of indigo and Winsor red with the earlier washes of Thalo blue and Winsor red. Later, after my earlier washes had dried, I used some direct strokes of indigo and Winsor red to accentuate some of the ripples.

Q: I want to explore different ways of creating textures. Can you give me any ideas?

A: You can use your fingernails or a sharp-pointed stick to create fine lines, or tissues and towels to blur and blend colors. With natural sponges, you can make random patterns, while manmade sponges offer uniform textures. Meshed materials and salt can also be used to produce unique effects.

There are countless possibilities. You can use your fingertips, fingernails, or a sharp-pointed stick to create delightful smudges and fine grass lines and twigs. Try using a wadded paper towel to apply color, or tissue to blot out and create fleecy clouds or frothy waves. Natural sponges provide an excellent way of developing controlled as well as random textural patterns. I keep several sizes available in the studio. Those I use most often are no larger than 2 x 3″. A sponge can make a delightful tree, especially small maples and fruit trees in bloom, as you saw earlier on page 39. With cheap grocery-store sponges that measure approximately 4 x 2½″, you can produce uniform predictable textures for concrete walls, sidewalks, and so on. Use your imagination and always be on the lookout for new ideas, but use a little finesse. Personally, I get turned off by cutesy gimmicks that wind up overpowering the painting itself—sometimes the results can look like technique for technique's sake. Try to avoid this.

For this painting, I used a fairly wet sponge. The little spots of color on the fringes of the shape were applied last, after most of the moisture had been pressed out of the sponge. You will also find that you can glaze with a sponge, creating mixtures of colors and shapes to make a natural-looking tangle of scrub growth, grasses, weeds, or patches of wildflowers.

In this example, I used a dry manmade sponge to apply several layers of pale Thalo blue, new gamboge, and vermilion. I repeatedly picked up pools of color washes and laid them down flatly on the paper until a pleasing texture was built up. I left the wash fairly weak on the left side of the example, so you could see what the first layer of wash looked like. As I approached the window, I darkened the wash by increasing the amounts of red, blue, and yellow. For the final touch, I then used a square-edged brush to paint around the windowsill to strengthen the shadow effect. I used the same color that I used with the sponge. This wash acted like a glaze to unify all of the previous sponge work. Instead of dry brush, I suppose you could call this dry sponge.

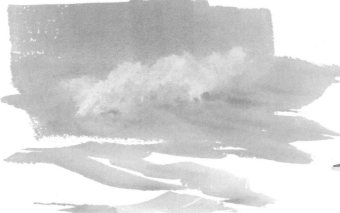

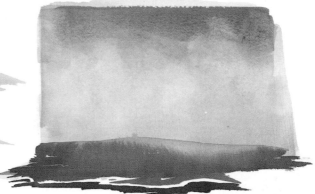

The crest of the wave in the middle ground of this example was blotted out with tissue just before the wash dried. If I had blotted sooner the crest would appear lighter than it does here. I suggested waves in the foreground by using a square-edged brush. These highlights can be dulled by applying another wash to cover the pure white of the paper.

Here, a fluffy, cloudy sky was achieved by blotting the sky washes with a facial tissue. Each time I applied a wash to the sky, I blotted the area with tissue while it was damp. After each layer dried, the process was repeated.

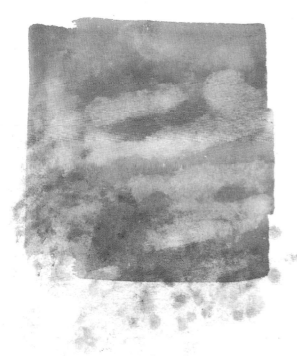

The foliage just above the horizon was created with my fingertips. I made the dark marks while the wash was very wet, so that the wash seeped into the gouges in the paper. For lighter lines, you need to wait until the wash is almost dry, and then scrape. Fingernails or a sharp brush handle will scrape away pigment to expose the white of the paper—or a previously dried staining wash.

This sample shows the types of texture that can be created using a paper towel. First a flat wash was applied. Before the wash dried, I laid a piece of paper towel across the wash and tapped it with my fingers. Then I lifted it from the wash. The result can be clearly seen in the upper portion of the wash block. The lower section shows the effect of daubing color over the previous wash.

For a splattering texture, I used a toothbrush.

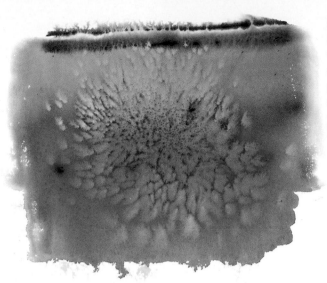

Here I used table salt to create an unusual texture. First I applied a wash of Thalo blue and Winsor violet, allowing the two colors to mix on the brush as I pulled them through a dampened patch on the paper. Then I used a salt shaker to sprinkle salt over the middle of the wash to create the pattern you see. You might consider using salt to render lichen on boulders or other such imagery.

Using a large square-edged bristle brush, I held the nylon mesh in place with one hand and the brush with the other.

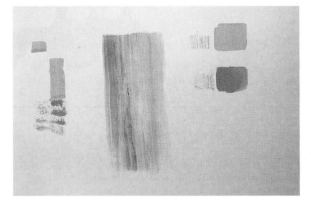

To create the effect of wood grain, I used the dry brush to drag the wash along the paper. Then I dragged a second darker wash over the previous one. Here I used the darkest color both as a glaze and as a dry-brush element. It was used as a glaze on the left side of the plank and to strengthen the shadows around the knots.

In this study of a honeycomb, I used a manmade pattern in conjunction with the glazing technique. First I brushed in the basic shape of the nest with its lights and darks. The areas that I wanted highlighted were left pure white; the shadow areas were darkened using several washes of color. Once the desired balance between shape, and light and dark had been established, it was time to define the cells. Working with a large square-edged bristle brush, I began to apply darker color over the mesh. The mesh was positioned in a manner imitative of the way a nest is constructed.

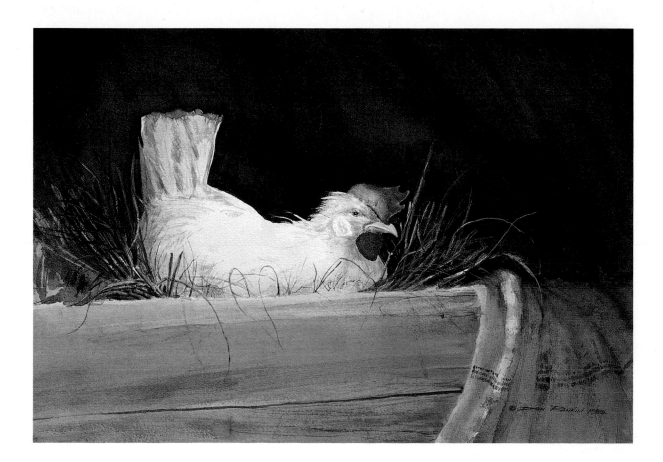

Settin' Hen. Watercolor on 140 lb. cold-pressed D'Arches paper, 15 x 22" (38 x 56 cm). Collection of the artist.

To begin, I painted the background with a bright orange underpainting, taking care to avoid the white hen, the plank, and the portion of the draped burlap bag. Once the orange was dry, I dampened the paper and applied a very dark mixture of India ink and vermilion. I used a bristle brush to disturb the wash when it was still slightly damp. Just before the wash was completely dry, I used the sharp handle of an aquarelle brush to pull some of the dark color out around the chicken and toward the side near the burlap. The result is the straw you see. The planks were dry-brushed using a mixture of vermilion and Thalo blue with some of the darker ink mixture I used for the shadow between the planks. This textured surface was glazed with a wash of cerulean and manganese blue just to put some life into the piece. The overall burlap color is pale new gamboge and vermilion with just a hint of Thalo blue. I created the texture in the burlap bag by painting over a screen wire. It helped to put a regular pattern in the material and to create the texture I wanted.

Q: Can you give me some hints on creating mood with glazing?

A: Since color creates mood, the overlapping of colors in the glazing process is ideal for producing various atmospheric effects, from a misty dawn to a clear winter evening.

I almost always associate mood with color, even though subject matter naturally also plays a part. With glazing, you can create wispy, ethereal elements in a landscape or seascape, from a foggy or rainy atmosphere to a very crisp, clear one. Any one of these situations is going to help to contribute to the overall mood of your work. Whether you choose to wrap your painting in the somber tones of winter or the bright riot of spring, you are still dealing with color, and color is what glazing is all about. With glazing you can control the flow and the strength of color. You can successfully manage the amount of color and suggest the type of lighting effect you want in your painting.

Nightfall. Watercolor on 140 lb. cold-pressed D'Arches paper, 8¾ x 9″ (22 x 23 cm). Collection of the artist.

Maybe no artist can adequately capture the glory of a sunset, but with glazing one can come close. I began by applying a graded wash of new gamboge and Grumbacher Indian yellow down the sheet to the horizon line. I let this section dry completely. Then I mixed a redder yellow and washed it on. Once the sheet was dry, I turned it upside down on my drawing board and dampened it with clear water. Then I took a strong mixture of cobalt and ultramarine blue and washed it across the bottom of the sheet, allowing it to bleed into the yellow. This created a range of strong blue at the bottom of the sheet, and a lighter blue and slightly blue-green on the horizon. Because the value of the yellow and blue grew weaker as they approached the horizon from opposite directions, there is a layer of pale color floating between the sky and the ground.

After this wash was dry, I dampened the paper again and washed in a band of vermilion across the center of the page, allowing it to bleed up and down. When this was dry, I mixed up a strong wash of Winsor violet and applied it across the bottom of the sheet. After this dried, I mixed a strong wash of indigo and flooded it in the lower portion of the paper, leaving a hint of the violet around the tree trunks. Finally I used a mixture of Thalo blue and vermilion to convey the silhouetted tree trunks and tree limbs.

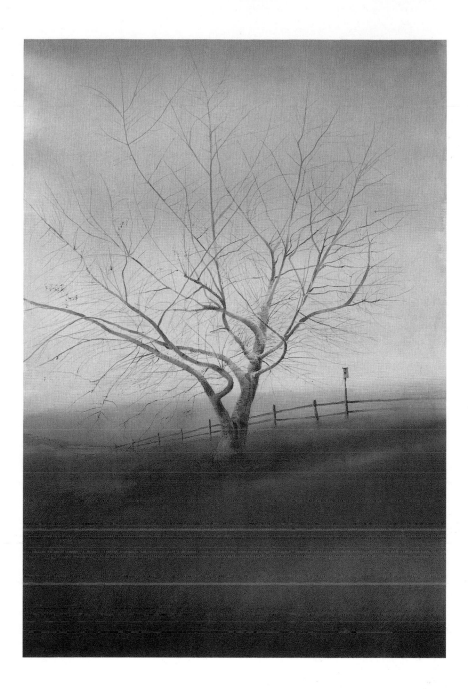

Apple Tree. Watercolor on 260 lb. cold-pressed D'Arches paper, 42 x 26″ (107 x 66 cm). Private collection.

I wanted to convey a soft peaceful mood in this watercolor. The entire sheet was washed with new gamboge and Thalo blue. It should be obvious that the new gamboge is in predominance. In the foreground, I used an even stronger mix of new gamboge, and feathered it out to nothingness on the horizon. This helps to give an ethereal quality to the overall landscape. I created the grass texture using Thalo blue and vermilion mixed with new gamboge to create the darker wisps of grass. As you examine the progression of tones in the foreground, you can see that the color goes from a light blue dominance to a red dominance around the base of the tree. The tree began as a series of pale washes of Thalo blue and vermilion. Texture was created using a series of daubs and stipples with a half-dry brush. The fence and birdhouse were added toward the end of the painting session. The fence wash was diluted in some areas to give an atmospheric effect to the overall look. The final result is a soft, hazy watercolor that evokes a gentle, peaceful mood.

41

Q: Do I always have to use Thalo blue when I want to create an underpainting?

A: The color you choose should be transparent and reflect the mood of your subject matter, but it does not have to be Thalo blue.

Absolutely not. It all depends on the mood or effect you are trying to achieve. One word of caution: Try to make sure that you use a transparent color that will not lift easily from the paper. It should be able to withstand repeated washing without lifting or bleeding. Naturally this is going to limit you to a few colors. Thalo blue is a good workhorse when it comes to underpainting. However, I have successfully used cadmium orange, Winsor violet, indigo, Winsor red, pale (dilute) vermilion, new gamboge, and Thalo yellow-green for underpaintings. The role of the underpainting should be a constructive role to help develop the mood, form, and texture of the painting.

The best way for you to know if a color will work as an underpainting is to try it. You may be delightfully surprised.

All Hallow's Eve. Watercolor on 140 lb. cold-pressed D'Arches paper, 18 x 36″ (46 x 91 cm). Collection of the artist.

I painted this watercolor to have a record of one of the pumpkins I carved for my son and daughter when they were very young. After an initial sketch, I washed the entire sheet with new gamboge. The first wash is still visible in the highlights of the teeth and eyes, and on the forehead. Next I applied a wash of cadmium orange on most areas of the pumpkin face and allowed it to dry. I consider this cadmium orange to be a part of the underpainting, because I knew from the beginning that I wanted the strength of the yellow underneath the orange. Since I knew I was going to make everything dark and somber around the pumpkin, I wanted a great deal of bright color underneath all that darkness to keep the painting alive. Once the orange was dry, I began to flood dark washes of vermilion and Thalo blue into the background. The dark part of the fireplace is indigo, Thalo blue, and Winsor red.

Rising Mist. Watercolor on 140 lb. cold-pressed D'Arches paper, 22½ x 34½" (57 x 88 cm).
Collection of the artist.

In this piece, I was intrigued with the color of the evening mist as it rose off the water and could be seen against the backdrop of the trees. I used the color of the horizon to create the underpainting, which consisted of a mixture of Winsor violet and Winsor red. Once this underpainting had dried, I applied a sky wash of new gamboge, Thalo blue, and vermilion. After the sky was dry, I dampened it again to get a soft wet-on-wet effect for the trees on the horizon line. The water caused the mixture to separate, creating the red halo at the top of the trees.

While this was drying, I brought some of the color down into the water in the middle ground. If you look at the horizon line, you will see the white of the paper. I used this white division to prevent the wet-on-wet effect from drifting down into the rest of the painting and to produce a highlight along the water's edge. When the sheet was completely dry, I created the dark tree line by brushing a mixture of indigo, Thalo blue, and Winsor red directly onto the dry paper. I used the flat side of a square-edged brush, which I dampened with clear water to feather the bottom edge of the dark wash; this created the effect of mist below the trees. A lot of this same wash was used in the rocks and shadows in both the middle ground and foreground. The green tones in the foreground are a mixture of Thalo blue and new gamboge. The rough texture of the immediate foreground was created with a dry brush, as were the vertical reflections in some of the puddles.

42

Q: If I want to use the underpainting technique, do I have to cover the whole sheet of paper with the color?

A: The underpainting you need depends on the effects you want to achieve. You can cover a portion or all of your paper with an underpainting.

You are in complete control on the amount of underpainting needed for your painting. The only factor that dictates the amount of underpainting you use is the effect you want to obtain. Remember that an underpainting will enable you to achieve more texture and form, or help you evoke a particular mood with color in your painting.

When you want to capture a particular likeness, you can use a carefully executed underpainting to "hold" the likeness as you develop the painting. In such a case, you may want to prepare a sketch and then carefully apply the underpainting. You can also develop an underpainting with light and dark values to add depth and power to your painting. Make sure you use the full range of light and dark values of whatever color you choose. In each case, you may cover a portion or all of the paper to create the effect you desire.

This underpainting gives you a strong indication of how the finished painting will look. First you should notice that the range of blue values runs from light to dark. The values are clearly defined; they almost mimic a black-and-white photo, except in this case it is a blue-and-white rendition. Some areas of the underpainting were painted in directly on dry paper; while other areas were done with the wet-on-wet technique. Every stroke, every shape is there to create a certain effect, to suggest a particular quality of light, or to define a certain texture. Notice that not every area in this underpainting has been covered with color, only the areas that *needed* color.

Country Church. Watercolor on 260 lb. cold-pressed D'Arches paper, 33 x 21" (84 x 53 cm). Private collection.

There is a very small yet important amount of underpainting in this watercolor. In this case, I wanted to preserve a likeness and a color effect. First I prepared a sketch, and then I carefully executed an underpainting. I used a pale yellowish underpainting (a mixture of Thalo blue with new gamboge that was diluted with water) on the plank shadows and window detailing. On a white wall, this pale wash has a great deal of power. The underpainting in this situation merely covered the bare essentials. I wanted the wall to be felt as well as seen. If a great deal of linear detailing had been used, it would have confined the flow of the white shapes that make up the window and wall.

The shadow areas were created with a carefully modulated mixture of new gamboge and a trace amount of Thalo blue. The first major wash was used to define the form of the window. The sash itself is pure white watercolor paper. With this basic division established, I began to work in the window. As I developed one pane with a particular wash, I would move to another pane to keep each element progressing at the same level. The colors used in the window include new gamboge, vermilion, Winsor violet, and Thalo blue with some cerulean and manganese blue. A combination of direct washes as well as wet-on-wet applications were used to create the effect you see. To create the soft lighting effect, I dampened the shadow lines and applied a darker wash next to the edge of the windowsill on the right side. This darker wash bled into the shadow underpainting.

43

Q: Can I use more than one color for an underpainting in the same piece?

A: Definitely. With more than one color in your underpainting, you can produce more complexity in the color, value, texture, and depth of your painting.

By using more than one color in your underpainting, you can produce a great deal of color, textural, and spatial impact. Since glazing is about the layering of colors to build textures and define forms, you should feel at ease using more than one color for underpainting. Warm and cool colors can be used to create additional depth. For instance, you can enhance a dark-colored subject matter by using light, transparent colors in the underpainting. There is one word of caution, however. Remember that as you add color you are making the process a little more complex. Each color added to your palette allows more room for errors. By the same token, each color added to the underpainting creates additional intricacies. Be sure that you think out the process fairly well before you begin. You will find the added complexity to be well worth it in terms of the visual benefits you derive.

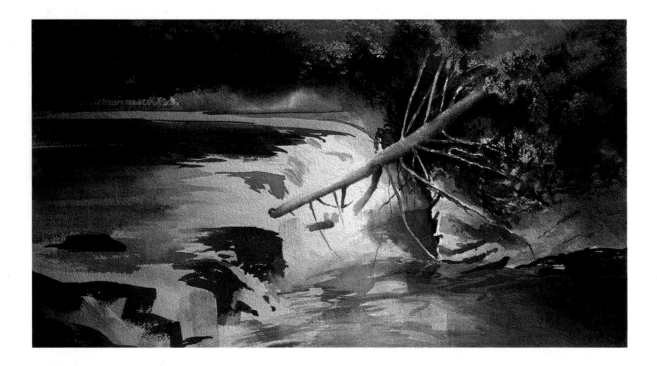

Mountain Stream. Watercolor on 140 lb. cold-pressed D'Arches paper, 11 x 14″ (28 x 36 cm). Collection of the artist.

I used new gamboge and Thalo blue for the underpainting in this watercolor. First I applied new gamboge at the top and at the bottom in the reflection area of the water. Once this passage was dry, Thalo blue was applied. The colors I wanted to capture in this mountain stream were dark. The water was nearly black, and the surrounding trees contained a lot of dark greens. Experience has taught me that dark colors can be greatly enhanced with a vivid contrasting under wash.

In this stage, I applied a clear water wash to dampen the paper. Then I painted a strong Thalo blue wash just under the edge of the dried new gamboge to create the misty blue area under the foliage. While this area was drying, I added a small amount of Winsor red to the Thalo wash and created the shadow pattern in the water just above the falls. (Note that I reserved the white of the dry paper between the two areas for a future reflection.) Taking the same wash mixture, I added more Winsor red and a little new gamboge to get the dark color for the rocks in the foreground and the shadow under the rock on the right side. Then I applied direct washes of Thalo blue and Winsor red with the side of a square-edged aquarelle brush to create the effect of foliage. While this was drying, I applied a lighter wash of new gamboge and Winsor red to create the tan colors on the rocks.

Here a pale wash of Thalo blue and Winsor red was washed across the surface of the water just above the falls; some of this same color was brushed into the rippling water just below the falls. This neutral color helps to tie the larger shadow shapes together. Some of this wash was also used in the fallen tree and in the large rock beneath the tree. More Thalo blue with Winsor red and new gamboge was used to paint in the rippled surface below the falls. Additional darks made from Thalo blue and Winsor red were painted in around the tree limbs, in the shadow areas, and in the foliage. A pale wash of Thalo blue was also used to darken the white seam that had been left between the dark shadow in the water and the misty blue area below the foliage.

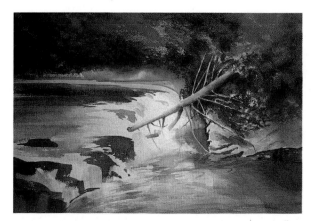

Many of the changes here are somewhat subtle. Small amounts of dark values were primarily used to refine and sharpen shadows and shapes around and underneath the tree. Deeper shadows were placed in some of the trees and in some of the shadows in the water. The objective was to refine the flow of the painting and the balance between the darks and the lights. From this watercolor, you can see how the two staining colors used in the underpainting helped to intensify what might have become a dull, drab scene. The strong yellow gives the dark greens a boost, and the Thalo blue underpainting in the water helps to add another element of color. While darker washes will certainly override the yellow, its presence will still be evident even under the darkest of value.

MULTICOLORED UNDERPAINTINGS

Q: Can I capture a certain time of day with underpainting?

Any time of day or any weather condition can be created using the glazing technique. To depict a particular time of day, you must know what characteristics will convey that condition visually. Therefore, you must sharpen your powers of observation. You need to ask yourself: What is the difference between the light at sunrise and the light at midday? How does it change toward sunset? Are the changes predictable, or do they change with the setting, the season, and the day's weather?

If you have any power of observation at all, you know that many of the lighting changes are subject to a whole host of conditions. Once you understand some of these conditions, then you will be better able to create a convincing visual portrayal. For example, sunrise and sunset have one thing in common. They are both low-light situations. The range between lights and darks is shortened so that you will have a very contrasty painting. These times of day can create some very dramatic color and contrast effects. As a general rule, the early morning light is cleaner or clearer than afternoon light. Afternoon light will usually be bathed in warmer yellow or yellow-red tones. However, even though the evening light may appear at times to be warm, many objects will be bathed in cooler shadows in the evening than in the morning. As the season approaches autumn and winter, the yellows and reds give rise to warm crimson and golden tones, depending on your local latitude. For example, sunset in February in Alabama is very similar in coloration to sunset in Nova Scotia in early June. The latitude makes the difference in the angle the sunlight strikes the surface of the earth.

A: An underpainting can set the tone for any time of the day—from a warm-colored afternoon to a cool, shadowy twilight.

Here the light is the beginning of dawn; many shadow areas are ill defined and seem to blend into one another. Look at the shooting stand with the two men and the shape of the boat with its reflection. Since the lighting is low key, the subtle distinctions in these areas are momentarily blurred. I chose to utilize a warm color in the underpainting because the rising sun would permeate everything with a warm glow. I made the horizon washes a little misty to suggest wisps of morning mist that will quickly burn off as the sun continues to rise. The cool blue-green wash helps add contrast to the warm oranges of the underpainting. In my mind, this color combination and the atmospheric effect of the lights and darks seem to suggest sunrise. The emotion and the time of day are clearly outlined in these first few simple washes.

It is midday, and the sun has risen. Early morning mists have burned away under the sunlight, and the lights and darks are clearly defined and established. You can see a definite division between the lights and the darks in the underpainting. There is also a wider range of tonal values in this underpainting than in the previous example. The reason for this is because the light is stronger and more values are revealed. There are definite hints of shadow and depth in the distant tree line, the shooting stand, and the reflections. Also, the clarity of the scene suggests a later time of day.

The sun has passed over and is now beginning to set. The distant tree line reflects the warm rays of a setting sun while the other objects take on a cool silhouette against the evening sky. The colors in this underpainting are Thalo blue, Winsor violet, and pale vermilion. This combination of colors suggests a setting sun with the coming of night. In just a short while everything will fade into black.

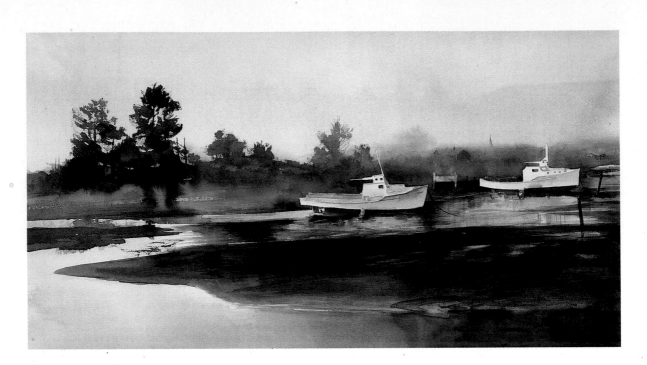

Kennebunkport. Watercolor on 260 lb. cold-pressed D'Arches paper, 26 x 42" (66 x 107 cm). Collection of the artist.

The season is late fall; the time is just before total sundown. The lighting is low key and the shadows are beginning to blend into darkness. My palette colors are new gamboge, indigo, manganese blue, Thalo blue, cerulean blue, Winsor violet, Winsor red, and Grumbacher red. I made sure that the sheet was evenly damp with clear water except for the boats before applying any color, so that the sky would be clear with no abrupt edges.

The first wash was an underpainting of dilute new gamboge, which suited the low-light situation. Everything with the exception of the two boat hulls received this color, and the wash was stronger in the land area than in the water.

Once the base wash was dry, I applied a very pale layer of Thalo blue with Winsor red across the paper, once again avoiding the boats. (These cool colors set the tone for an approaching nightfall.) The misty horizon was created by dampening the entire sky with clear water; then I applied a wash of Winsor violet and Thalo blue. Some of this wash was allowed to bleed upward into the damp sky, creating the illusion of trees.

Next I began to darken the immediate foreground using a mixture of Thalo blue, new gamboge, and Winsor red. This mixture was applied in at least three layers. I dampened the horizon again, and this time I added indigo and Thalo blue to the Winsor violet. Then I darkened the foreground a few degrees to harmonize and create the effect of sundown. Next I began to

develop the stand of pine trees on the left, using a strong wash of indigo and Thalo blue. As the wash came down into the violet, I dampened the paper to create a feathered edge that looks wild but was actually controlled. (If you practice varying the amounts of water and color, you can eventually judge about how far the color will spread.)

Now it was time to make adjustments in the reflection areas of the water. Immediately adjacent to the stand of pines I applied some of the indigo mixture to a dampened portion of the water to create a very dark reflection. Next I turned my attention to the boats. I had been careful in applying washes around the shape of the boats so that there were no unsightly edges. Therefore I was able to begin darkening the shadow passages around the boats. Both Grumbacher red and cooler Winsor red were used in the hulls and reflections. By playing these two colors against one another I was able to create a feeling of additional depth in the painting.

The final stage of adjustment came in the foreground. In the immediate foreground, the water was too bright, so I carefully dampened the water section with clear water. Into this area I flooded a wash of Thalo blue and Winsor red. The object was to create a gradual transition from light into dark here. Finally I added a little manganese blue to the foreground, to enliven that area and to harmonize with touches of blue in the background near the boats.

45

Q: What can I do to keep my washes from looking dull or heavy?

Washes that appear dull or heavy usually occur when you mix colors that do not interact well together. To avoid this problem, you should study your colors. Can you accurately describe the characteristics of every color on your palette? For instance, new gamboge is a transparent color while cadmium yellow medium is more opaque. Since more light passes through transparent colors, if you glaze over cadmium yellow medium with a transparent color such as Thalo blue, you will produce a dull color. In such a case, the more layers applied, the heavier the color becomes. You should have a basic knowledge of every color on your palette. The only real way to learn this is to paint and observe. When you understand pigment properties, you will avoid putting them in improper sequences that develop into dull, heavy colors.

You could also be using too much water on heavy paper. For example, the 300 lb. sheets have a tendency to hold more water because of their bulk. Water buildup isn't readily noticeable because the surface may appear to be dry. However, as your strong vibrant wash begins to dry, the extra water will rise up and dilute your color. The result is a dull passage of color. The solution is simple: Be aware that heavy paper will soak up more water. One easy rule to follow is to always use water sparingly, even on the thinner 140 lb. sheets. Use just enough to accomplish the task at hand and no more than that. For instance, if you are painting wet-on-wet, don't drown the sheet, just use enough water to moisten the surface of the paper. You will be rewarded with a stronger, more vibrant wash.

A: Make sure your pigments are applied in proper sequence, according to the way they behave in relation to one another. You should also use water sparingly, especially on heavy papers.

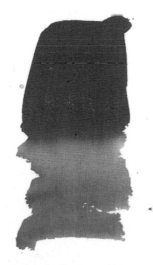

cadmium yellow medium

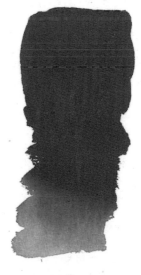

new gamboge

Compare these two samples of color. The first is cadmium yellow medium; the second is new gamboge. At first glance, they appear to be rather similar in hue. But if you look closely, you will see that new gamboge is more transparent than cadmium yellow medium. Light will pass through the new gamboge more easily than in the cadmium yellow medium.

Here I used one layer each of new gamboge and Thalo blue. The color is clean and vibrant—almost too vibrant. Notice how the paper surface looks cleaner here than in the example below.

This time I used one layer each of cadmium yellow and Thalo blue. The resulting wash is grainy. Although it looks okay now, with one or two more washes it would become quite dirty and dull.

46

Q: How do you get such powerful color effects with thin layers of wash?

A: Be careful to use transparent colors in the initial washes, and opaque colors in the final stages. Also allow each wash adequate drying time, and paint only on good-quality paper.

There are several factors that you have to keep in mind in order to get powerful colors with thin washes. First you must use good-quality watercolor paper. Then you must use transparent colors in your beginning washes. Make sure you give each wash adequate time to dry. As you work, be careful that you only use the more opaque colors in the final stages of your work, unless of course you are seeking some sort of special effect. If you will follow these guidelines, you too will produce vibrant, clean colors in your paintings. Once you get the basics down, you can turn your attention to nurturing your creativity and imagination.

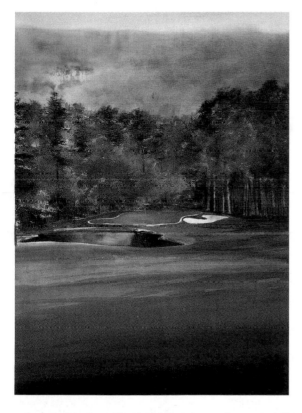

Hole Number Five, Shoal Creek. Watercolor on 260 lb. cold-pressed D'Arches paper, 40 x 24" (102 x 61 cm). Collection of Shoal Creek Golf Club.

The first wash was a dilute mixture of Thalo blue and vermilion for the sky. When this was dry, I flooded a wash of new gamboge over the remainder of the painting. This yellow wash was strongest in the trees and in the immediate foreground. After this wash was dry, in the foreground I quickly began to lay in broad washes of Thalo blue with a small amount of new gamboge to create a vibrant green. I used it in the areas where I wanted the green the most intense.

Then I applied a single wash of ultramarine blue to the mountain ridge, and began developing some of the tree line with washes of vermilion with Thalo blue in various areas. Next I began to develop the immediate foreground, applying a mixture of vermilion, new gamboge, and Thalo blue over the vibrant green. This was done to mute the vibrancy a bit to make it look rich yet natural.

Now I was ready to begin refining and developing detail. I started in the tree line, applying darker layers of wash consisting mainly of Thalo blue and vermilion. By altering the ratio of these two colors, I went from a graying color to a brownish wash, both of which can still be seen in the background. The nearer trees were created by painting the negative spaces between them with varying strengths of this same mixture of Thalo blue and vermilion.

With the tree line in place, I returned to the foreground and added another layer of dark color composed of a little indigo in a mix of Thalo blue and vermilion. Before applying the color, I dampened the paper almost to the lake. I wanted the shadow edge to blend smoothly. While this was drying, I began to define the greens around the hole. The variations in green were accomplished by altering the mixture of vermilion with the Thalo blue and new gamboge. The last green, the area around the hole, was a mixture of the same colors previously mentioned, but Thalo yellow-green was added to increase the vibrancy.

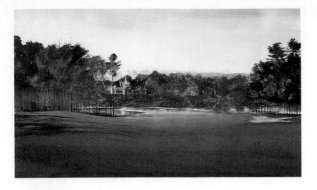

A View of the Clubhouse, Shoal Creek. Watercolor on 260 lb. cold-pressed D'Arches paper, 24 x 40" (61 x 102 cm). Collection of Shoal Creek Golf Club.

My primary concern here was the cross angle of sunlight as it swept the greens. The palette was the same for this piece as for the previous painting except I didn't use ultramarine blue. To develop the color effect you see in the foreground and middle ground, I applied an uneven wash of new gamboge in this area. Next I painted a layer of Thalo yellow-green all the way to the paper's edge in the foreground. I allowed the beach area to dry before carefully painting in the green. Finally the shadows in the foreground were applied. The darkest values are a mixture of Thalo blue, vermilion, and Thalo yellow-green. The lighter values were applied first. I applied most of the shadows to damp paper, allowing for a complete drying time in between washes. By using layer upon layer of wet-on-wet wash, I was able to achieve a pleasing soft-graded transition. The definite shadows on the left side of the green were painted in a direct manner using Thalo blue, vermilion, and indigo.

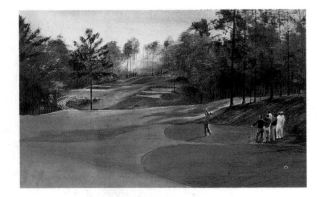

Foursome on Thirteen, Shoal Creek. Watercolor on 140 lb. cold-pressed D'Arches paper, 18 x 24" (46 x 61 cm). Collection of Shoal Creek Golf Club.

One afternoon I just happened to come over the ridge to catch this man teeing off. It was a natural for a painting.

My Thalo blue underpainting was strongest in the shadows of the pine thicket, and the contrast helps intensify the effect of sunlight breaking through the trees. Here the playing greens consist of Thalo yellow-green, and the surrounding grass is new gamboge, Thalo blue, and vermilion. The most intense colors were used in and around the players. Indigo and vermilion were used for the darkest values in the shadow areas of the foreground. The lighter shadow values are Thalo blue with vermilion. Each layer of color helped to produce the vibrant color range you see here.

Q: How can I keep my shadows from becoming dull, dark, and dead spaces?

A: Plan your shadows beforehand, and use contrasting early washes to boost your colors. Experiment with cool colors, and develop the local color before applying shadows.

For a number of years, I had treated shadows as negative spaces without thinking of their true value. Perhaps this came about because of the connotation that positive is good and negative is bad. If you have this subliminal attitude, it may cause you to disregard the worth of the negative state, making you think that the shadow is an area to be covered up and removed from the visual context. However, the shadow is a wonderful part of the painting. It doesn't have to be a black hole; it can be an area of inviting richness.

To create deep, interesting shadows, you should experiment with colors. Try using cool colors instead of dark ones. Take your time developing the shadow area. Try to build up the local color before you apply your shadow wash. To add a boost to your shadow colors, use a contrasting under wash, or glaze more than one layer of the shadow color in the same area.

The first color block contains new gamboge, and the second one has an orange blend of new gamboge and vermilion. After they had dried, I ran a brush with clear water down the center of each block to dampen the paper. Into each dampened area, I brushed in a mixture of vermilion with a small amount of black India ink, and allowed them to bleed. The darkest portion of each shadow color is on white paper, and then each bleeds over into a lighter under wash. It is easy to see how the under wash boosts the dark and gives it more life. Naturally, it will take more than one wash to darken this area, but having the underpainting provides a livelier shadow area.

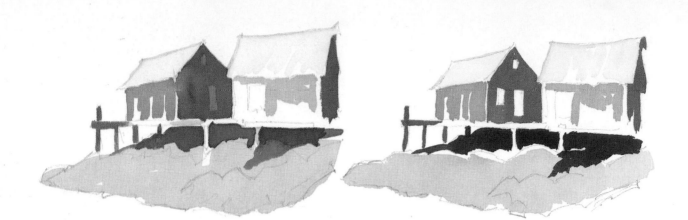

Compare these two studies of fishing shacks. The first sample has an underpainting in the shadow whereas the second one doesn't. The same colors were used on both pieces. In the first sample, I used an under wash of orange on the buildings with a green in the shadows under the shacks. I purposely left some of the color showing so you can see all of the elements that go together to make the image. You can see the difference a little extra color can make. The shadow side of the buildings has more color and life in the first sample. The second sample looks dull because there are no light colors under the washes to boost them.

Under the docks, the green under wash in the first case gives the feeling of reflected light and the illusion of detail in shadow. In the second case, the dark blue shadow is flat, dark, and dead.

You don't always have to put a contrasting under wash in a shadow area; you can merely layer more than one layer of your shadow color in the desired area. You will find the results more pleasing than one passage of dark shadow value. If you are using a powerful dark such as India ink, or indigo, work some variation into the shadow or shape, because a powerful color will overpower everything else and defeat your purpose.

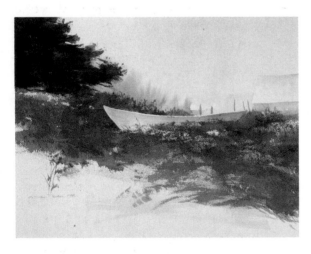

Morning Fog. Watercolor on 140 lb. cold-pressed D'Arches watercolor block, 14 x 20" (36 x 51 cm). Private collection.

This little watercolor was created by contrasting wet-on-wet washes against direct washes. First I dampened the paper and applied a layer of vermilion, new gamboge, and dilute Winsor violet. These colors were diluted to the point that they almost lost their identity. After the first wash had dried, the paper was dampened again and a mix of Thalo blue and vermilion wash was used on the horizon to create a tree line. I used new gamboge, then some Thalo yellow-green, and finally Thalo blue for the colors of the boat. To obtain the subtle shadow side of the boat, I brushed in Thalo blue with vermilion. Then I started to paint the tree with Thalo blue, but I didn't like the effect.

While it was drying, I was pondering my options and began working on other areas. I finally decided to make a bold statement with the dark tree area. I mixed up a strong portion of indigo and painted the tree in with several sweeps of the brush. My main objective was to produce variation in the wash and to allow some of the base colors to shine through. Notice how the strong color rivets your attention, and yet the shadows in and under the tree give the illusion of being transparent, not dead and dull.

Bass Harbor Light. Watercolor on 140 lb. cold-pressed D'Arches paper, 19½ x 25½" (50 x 65 cm). Collection of the artist.

I have depicted this site in the past and still am intrigued by it. This particular attempt pleases me because of the transitions of light into dark that I was able to achieve. New gamboge plays a vital role in this painting. In fact, the entire sheet with the exception of the highlighted side of the lighthouse got washed down with new gamboge. Once the initial wash was in place and dry, I began to strengthen the new gamboge in the bank. After enough of the yellow was in place, I switched to vermilion. The vermilion was used in several strengths. The shadow side of the lighthouse received a light wash and the rocky bank received a stronger wash.

While this was drying, I developed the sky, using a wash of manganese blue and a mixture of vermilion and Thalo blue in a small area. Next I mixed a gray from vermilion and Thalo blue. In varying strengths and numbers of layers, this color formed the roof, the dormer, and the shadow side of the house. I painted the window Thalo blue, deliberately varying the intensity to suggest a

subdued reflection. To create a strong, interesting shadow in the rocky bank, I applied washes of vermilion and Thalo blue to that area. I had it developed to the stage where it was almost ready to go dark, so I mixed up a portion of Winsor violet and ultramarine blue. Then I dampened the entire bank area with clear water. Using a large square-edged brush, I applied this mixture of blue-violet and allowed it to flow from top to bottom. I blotted out some of the wash when it approached the lighter portion of the bank.

After this had dried, I saw that the effect had worked. Some of the ultramarine blue was floating in the dark wash, producing a dark, smoky effect. I used dilute Winsor violet and Thalo blue on the lower left portion of the bank for a different effect. With this portion completed, I mixed my final and darkest wash of vermilion and black India ink. I brushed this color in directly on dry paper to create the stand of trees. While all of this dark was drying, I was checking for any rough spots or areas that needed additional refining.

Q: Do you have any secrets for creating dark passages of color?

A: Use a cup or bowl to mix your dark wash in, and load your brush from the container. This concentrates the color.

I learned this secret several years ago, and it is one of the most effective ways of creating dark passages. I should give credit to John Pike for this idea for he mentioned it many years ago. If you need a really strong dark for shadows or contrasting, mix the color in a cup or a bowl.

The reason this works is very basic. When you mix color on your palette, your brush can absorb just so much paint. But when you immerse the brush into a bowl or other container, you are able to load the brush to the fullest. When you apply this type of wash across a sheet (either wet or dry), you've got a lot of concentrated, powerful color on your hands. I used this method on the golf course series as well as *Bass Harbor Light*. I don't use it all the time, but it is an excellent way for you to super-charge some of your darker passages.

The color you mix in the bowl should not be any thicker than the color you would mix on your palette. You'll have to experiment with this because you can really load up too much color this way and produce a very opaque passage even with transparent watercolors. Try this technique on scrap paper before you try it on a painting.

Use a cup, bowl, or any other container that will allow you to immerse a brush into a dark wash. This will enable you to concentrate the power of the wash to create darker passages.

49

Q: Can an underpainting help me create a believable portrait or figure painting?

Underpainting techniques can very definitely help you create a believable portrait or figure. To determine the color of your underpainting, you must take into consideration your model's complexion and the prevailing light. Then you need to establish the large shapes and plan your lights and darks. Once this basic information is translated into your underpainting, you will be able to develop your painting with less complications. The proper use of an underpainting will help to set the stage for a wide range of textural development as well as to develop form and powerful lighting situations.

Glazing is like going on a voyage into new territory. You don't really know precisely what is going to happen, but you try to be prepared for any eventuality. In order to help explain my premise, I have chosen to divide the following painting into eight critical stages of development. In this painting of my son, I used the glazing technique to build a mood. After the mood was carefully set, I applied essential details to complete a convincing portrait. It would have been easier for me to paint a hard-edged painting, similar to a black-and-white photo. However, that would not have satisfied my desire to accentuate the quality of light that danced through the window on that particular day. By alternating my use of the wet-on-wet technique with the direct wash in a controlled glazing technique, I was able to create some very pleasing and subtle effects while I was creating a portrait.

A: The underpainting can set the mood for a portrait or figure painting. You can establish the major color tones, the main shapes, and the lights and darks in your underpainting.

This is a photo of my son David as he appeared when he was eleven years old. I had this black-and-white photo for two years before it evolved into a painting in my mind. When I saw the contact sheet, I knew that I had captured my son in one of his special unguarded moments.

My sketch gave me an opportunity to explore capturing David's likeness. In order to obtain the likeness, I had to get a few delicate shapes to relate to one another properly. There is no magic, secret approach to this—the answer is simply to work at it and be analytical if necessary.

The first step after the sketch was to create a thorough underpainting, one that begins to establish not only composition but mood. I chose Thalo blue because it is an agreeable, versatile, and powerful transparent staining color. The tree shapes outside the window become less intense as they approach David's head; this prepares for a reflection I will add later. The shadows behind him are lighter than they will finally appear, to prevent blue from overpowering the painting. Also notice the edge of the sketchbook as it projects into the shadow and the modeling of shadow on the body and arm. Compare this stage to the final painting.

When I add color to this foundation, interesting visual changes begin to take place. Here I have continued the development by applying a dilute wash of new gamboge to the background and to the figure. The color in the background is darker because I add a small amount of vermilion to the new gamboge. This section would produce the illusion of being darker merely because of the strength of the underpainting.

My objective here was to create a strong contrast between the shadows of the interior and the light as it played on the subject and the surrounding areas. The stronger color in the shadow area helps to set the mood and ensures that the shadow area will be rich in color even though it may be very dark in the final piece.

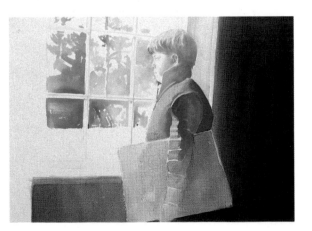

I want the image to dance in and out of the light just as it did when I saw it for the very first time. This requires a careful balance between direct and wet-on-wet washes. In my mind, the image that is depicted outside the window is secondary to the figure and the interior shadows. Once the interior elements are in proper relationship to one another, it will be easy to give the window the right amount of contrast. With this plan in mind, I continued to apply washes of new gamboge with a little vermilion to the shadow area. Note that the edge of the windowsill is beginning to emerge. This is because I chose not to apply any wash to the small horizontal strip just below the window. The flesh and the hair received another layer of new gamboge. The most obvious areas of development in this stage are in the vest and the shirt sleeve. Then I applied another wash of new gamboge and vermilion to the shadow area behind the figure. Everything is being treated as large shapes right now. Since I am still developing the mood, this isn't the time to get into detail.

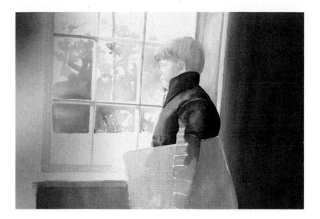

Now I am ready to establish some stronger areas of color. I chose to use the vest as a focal point because I saw it as a pivotal point. The vest with shadow and light playing on it serves as a perfect location for me to establish some strong color. The color mixture is a combination of new gamboge, vermilion, and Thalo blue. I dampened the vest with clear water, and then applied a mixture of new gamboge, vermilion, and Thalo blue, allowing soft edges to form. Very little, if any, color was allowed to bleed into the highlighted areas of the vest. The highlighted area is made up of the previous washes. While the vest was drying, I applied a little more new gamboge and vermilion to the hair, using the wet-on-wet technique. By this time, the vest was dry, and I added shadow tone in the upper part of the sleeve.

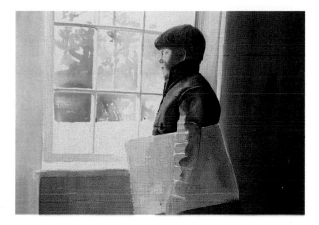

Here, dramatic changes begin to develop. First I applied a flesh tone wash to the figure, using a mixture of dilute vermilion mixed with some new gamboge. The wash was applied to the face—covering the ear and blending into the hairline—and hands. My greatest concern was to apply substantial color but to avoid hard definite edges. The shadow areas of wash composed of new gamboge, vermilion, and Thalo blue were carefully designed as shapes to help give form to the figure. The same washes with different color proportions were used in the hair. In some of the shadow areas in the ear and hair, I used strong washes of vermilion to keep the shadows lively. The blue underpainting helps to accentuate natural shadows in the hair; the yellow-gold tone of the new gamboge suggests the warmer highlights; and the vermilion mixed with new gamboge produces a strong golden red hue. Study the brushstrokes to see how they suggest hair. To suggest strong light and shadow, I applied a wash of new gamboge behind the arm on the large sketch pad.

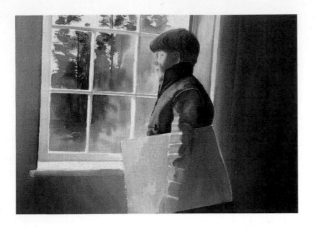

Now that the figure has become strongly established, I am ready to handle the window image. For the glass, I wanted to create a range from totally transparent to a semi-reflective state. On the left, you can see that I have made a sharp view of the trees, which also has strong contrast. At the center of the window, however, the image begins to become a little obscure. This is the beginning of a subtle hint of reflection impairing the view through the glass. This reflection is caused by the dust on the window and the light reflecting off the figure. I worked my trees in as broad shapes, using the wet-on-wet technique. For the color effect you see here, I used new gamboge, vermilion, and Winsor olive green. Then I began to strengthen the window areas with vermilion and Thalo blue washes of increasing strength. I also used some of this mixture in stronger proportions to wash shadow areas under the windowsill, and below and behind the figure.

Finally, the painting has been blocked in and the mood is set. Now it is time to begin refining key areas and adding subtle detail. To start this, I sharpened much of the window detailing with a no. 6 series 7 Winsor & Newton red sable brush, using darker washes of Thalo blue and vermilion. The fine limbs on the trees, the shapes of some of the foliage areas, and the figure also received refinements. Notice that now the hair is a bit more defined as well as the shadows on the side of the face and in the ear. The quality of reflected light near the rear of the ear is now more prominent. If you look back at this point to the example of the underpainting, you can compare it to this stage and see the hint of this reflection. Finally, you will notice the plaid design in the shirt sleeve and the additional modeling of color in the sketchbook.

Now all detail, except for the lettering on the sketchbook, has been executed. With all of the basic details in place, it was time for me to make final adjustments in shadow relationships between the various elements. The shadow area below and behind the sketchbook received a final layer of Thalo blue and Winsor red, with the blue dominant to help darken the shadow area. I strengthened the shadows around the collar and neck. Next I fully defined the shadow around the eye, and then the eye was painted in. Final adjustments were also made in the shadows of the clothing.

In this final stage, I used a mixture of Thalo blue and Winsor olive-green to create the lettering on the sketch pad. In reality these letters are much lighter than they appear on the actual pad. However, I felt that making them more intense would upset the balance of color and contrast I had created in the painting. After the lettering was carefully brushed in, I added shadows to some of the edges of the pad to give it a roughed up, worn look. Finally, I added the wire spiral binding at the top of the pad. Taking one final look at the overall painting, I placed some color on the collar of the shirt, and then at last I considered the painting completed.

David. Watercolor on 260 lb. cold-pressed D'Arches paper, 20¾ x 26″ (53 x 66 cm.) Collection of Geneal Rankin.

Instead of simply copying a black-and-white photo, I wanted to capture a certain mood and to accentuate the quality of light as it danced through the window on a particular day. By using a controlled glazing technique, I was able to create some very pleasing and subtle effects at the same time I was creating a portrait.

50

Q: I need some hints on creating convincing hair. Can I use glazing?

Glazing can be of tremendous help in creating both the lighting and the illusion of texture in hair. Since you are building color through layers, it gives you the opportunity to develop texture on several levels as the work progresses. Glazing gives you the choice of dry-brushing, scratching out, or combining opaque paints with transparent ones to develop hair. The options are many and varied. But if you are having trouble with hair, it may be that the problem lies deeper than merely choosing a workable technique. Like any other subject, the more you know about hair, the better you will be able to depict it.

First you must accurately express the form that lies beneath the hair. If you fail to paint the form correctly, superbly rendered hair will be of little value. When you begin painting hair, whether it be animal or human, you must capture the underlying form. Once this is done, you can progress to the next step.

Next you must study the consistency of the hair. Is the hair straight, curly, or wavy? How does the hair fall? Is it long or short? Work on basic shapes to capture the overall essence of the hair. Once the overall shape and character have been established, then you can seek to render some detail. Certainly hair is made up of individual strands, but you shouldn't set out to paint every one. Instead you should create the illusion that you have painted each strand.

A: Glazing is an excellent way to build up layers of colors to create various textures and highlights in the hair.

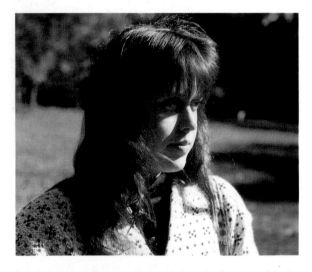

To gain an understanding of the challenge of hair, study this color photo of my daughter Carol. She is an unsuspecting model in this study.

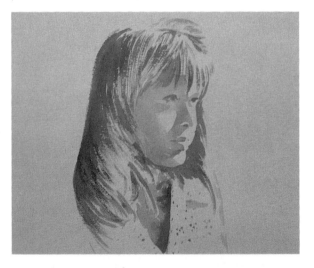

For this study, I chose to use a red underpainting, because it is the predominant color that I see in this photo. By using a 1-inch aquarelle brush and a no. 6 series 7 sable brush, I was able to develop the overall form of the hair, capturing the essence of what I was seeing that day. In Carol's sweater, the underpainting was dilute vermilion with Grumbacher red deep. I used vermilion on the face, and all flesh and hair areas.

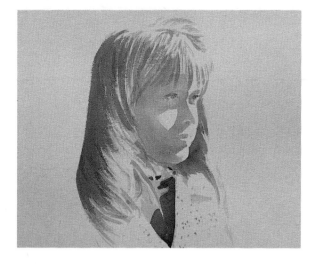

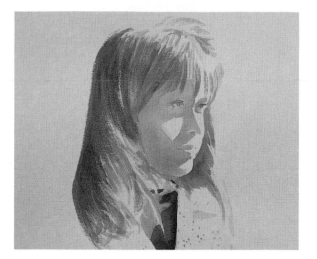

With the basics firmly in place, it was time to begin developing the image by darkening several areas. First I added the shadow to the left side of Carol's face. This area was darkened by adding a little Thalo blue to the vermilion. Using this same wash, I darkened some of the shadows in the hair around the crown of the head. I also darkened the shadows around the eyes, and I added eyelashes and eye details. In addition, I darkened the reds in the sweater.

Here I continued to darken selective portions of the hair. While the hair mass was beginning to look detailed, I was painting the hair in strokes imitating the flow of the hair, but I was not trying to paint individual strands. If you review the last few steps, you can see that the hair has developed from a general mass to a more refined one. All of the shadows in the face, eyes, and sweater were gradually being darkened and sharpened.

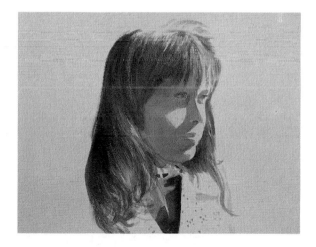

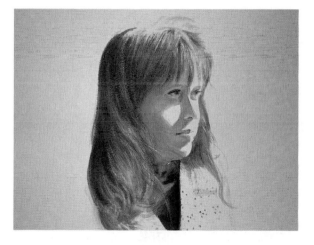

By continuing to alternate long flowing strokes with a series 7 brush, I was creating the illusion of a large mass of flowing hair made up of individual strands. But even at this stage, I had not attempted to paint any individual hairs. I was still setting the stage for a little detailing in the final moments. I continued to use the same basic wash, occasionally using darker mixtures in some of the shadow areas. While the hair was developing, I was also making sure that the facial shadows and details kept up with the rest of the painting.

Now it was time to paint individual hairs. However, these hairs are located only in strategic spots. Their presence is calculated to give the illusion that the entire mass has been painted that way. Some of the highlights were scraped out with the sharp point of an X-Acto knife. There is one near the right cheek but most of the hairs are dark. You will also note that in this final stage the eyes and other facial details received final adjustments.

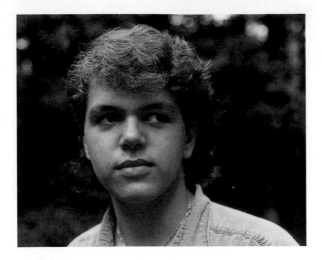

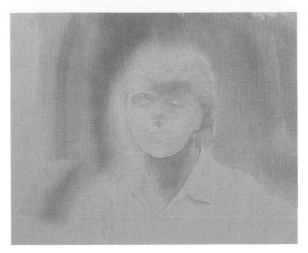

Compare the underpainting with the photo to see what characteristics I was attempting to capture.

In this study of a young man named Todd, I used a blue underpainting to establish the features and the hair characteristics. The Thalo blue was used to establish the basic shapes in the hair, face, and shirt. As you study the hair, you can see masses of detailing in the shadow areas as well as the highlights.

After the blue under wash was in place, I flooded the background with a pale wash of new gamboge. The face was a pale wash of vermilion; the neck was two layers of the same color. I was seeking to establish a sound shadow relationship very early. This can save a lot of painting and adjusting later. Keep everything loose or flexible, but make sure your relationships are accurate.

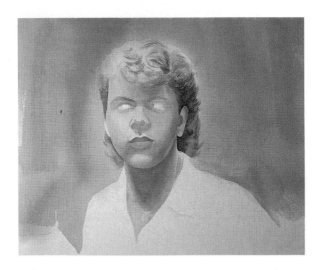

Here I began to develop the likeness and the hair characteristics rather rapidly. The facial shadows are vermilion with Thalo blue. I feathered the edges of the facial shadows with clear water where they needed softening. The lips are darker mixtures of the same color. The hair is a mixture of Thalo blue, vermilion, and new gamboge. Once again, I painted the hair in the manner in which it grows—that is, from the scalp outward. Some of the shadow areas, such as his right side, were being treated as a large mass. While some detailing was beginning to develop on his left side, it was still primarily mass. You will notice that in some areas the vermilion in the wash is predominant, and in other areas the yellow-brown is dominant. Also notice that in some areas, the hair is blending in with the background. This helped to convey a feeling of softness in the hair. The background was darkened at this stage using a dilute wash of Thalo blue and vermilion.